105150

KT-556-498

WITHDRAWN FROM
ST HELENS COLLEGE LIBRARY

Photography

A RotoVision Book
Published and distributed by RotoVision SA
Rue du Bugnon 7
CH–1299 Crans-Pres-Celigny
Switzerland

RotoVision SA, Sales & Production Office
Sheridan House, 112 – 116 Western Road
Hove, East Sussex BN3 1DD, UK

Tel: +44 (0) 1273 72 72 68
Fax: +44 (0) 1273 72 72 69
E-mail: sales@roto vision.com

Distributed to the trade in the United States by:
Watson-Guptill Publications
1515 Broadway
New York, NY 10036

ST. HELENS
COLLEGE

778·9

105150

MAY 2002

LIBRARY

RotoVision

Copyright © RotoVision SA 2001

All rights reserved. No Part of this publication may be reproduced, stored in a retrieval system or transmitted
in any form or by means, electronic, mechanical, photocopying, recording or otherwise, without the permission
of the copyright holder.

The products, trademarks, logos and proprietary shapes used in used in this book are copyrighted or otherwise
protected by legislation and cannot be reproduced without the permission of the holder of the rights.

ISBN 2–88046-575-3

Book design by Dan Moscrop at navyblue design consultants

Publication and separations in Singapore by ProVision Pte. Ltd.
Tel: + 65 334 7720
Fax: + 65 334 7721

Printed and bound in China by Midas Printing Limited

Introduction

This is a book that's as much about images as it is about technique. It's as much about having an eye for a picture as it is about having a mastery of the technicalities of black and white. And hopefully, for all the things that are passed on through the words of the photographers who created this collection of incredible images, one of the main benefits of the book will be its ability simply to inspire. If, having seen the quality and the sheer breadth of imagery that makes up these pages you feel the irresistible urge to pick up a camera and to go off and try some of the ideas for yourself, then the book will have achieved its purpose in style.

Photojournalism has so many aspects to it that in many ways it's difficult to produce just one book that will do the complete job. Certainly it would be almost impossible for a single photographer using his or her own pictures as examples to try and explain the variety of ways that this subject can be tackled. The approach to this discipline can be many things, as you'll see throughout this book. When a master photographer such as Tom Stoddart or Dario Mitidieri brings their compassion and understanding to a situation, it can result in an image that freezes in time its most poignant or telling moment. This is turn allows the viewer to respond in a way that they could never do to a moving sequence, which hurtles in front of their eyes and is then gone forever.

The work of a photojournalist might involve throwing light onto stories that those in power wish to keep in the shadows or it might be a single-minded mission designed to bring attention to cause or a situation — such as the AIDs crisis — that much of the world's press appears happy to ignore. It could be a picture that will break hearts or one that will inspire anger and the price of bringing it back might be the mental or physical well being of the person behind the camera.

Photojournalism could also be the coverage of an important and moving story that exists almost unnoticed in the middle of society, such as the terrible disease anorexia, and which can only be fully explored over months or even years. Even then the pictures will only come when, as Felicia Webb has done, long-term work has been put in to gain the trust and co-operation of those most directly involved.

There is also a lighter side to photojournalism, the one that can bring a wry smile to the face at the absurdity of the human race. Here the skill of photographers such as Bryn Campbell, David Gibson and Thurston Hopkins is to find the angle or the gesture that others would all too easily miss and which change the meaning of everything. Humour is there at every turn for those who know where to look and it's only right that, along with the more traumatic stories, the gentler face of human nature is a subject that is ripe to explore.

A photojournalist might take one picture in a 1/125sec that will last a lifetime, as with Eamonn McCabe's dramatic image of the panic of football fans as the Heysel Stadium disaster unfolds. They might also choose to pursue a story, such as Jill Waterman's documenting of New Year's Eve celebrations around the world, that builds up slowly to become a powerful and important record through the breadth of its coverage. Sometimes it's the legendary 'decisive moment' that is the key, a photographer such as David Modell or John Downing producing an image where everything for one split second has worked together before the world moves on and the instant is over. That's the beauty of this and so many other photographic subjects: the individual can make of it what they will, there's no set agenda that has to be followed. Even the golden rules that others have established over the years for photographers to follow are there to be broken and turned on their heads, as so many of the photographers featured here take the greatest delight in proving over and over again.

So much for the subject: what about the medium? What is it about black and white that makes it so enduring? Sheer logic should dictate that, with colour film so accessible and of such high quality now, that black and white should have been relegated to the history books long ago. But instead the opposite has happened. It's taken on a new life of its own, and is gaining a steady and growing following across the world.

Black and white is now seen as the natural medium for fine art prints and, as the digital side of photography becomes ever more important, those who choose to indulge in silver halide and the skills of the darkroom will increasingly be seen as artists in their own right.

A whole new generation of photographers is discovering that black and white can offer them a different way of looking at the world, one in which the simplicity and subtlety of tone and shadow triumphs over the distractions of colour. Time and again black and white somehow captures a mood and a feeling that colour, for all its accuracy, simply can't. Perhaps that's exactly the point: photography is about so much more than a simple rendering of what's in front of the camera. We want to achieve an interpretation of life, and colour somehow sometimes gets in the way.

There's also a lot more flexibility built into black and white in the way that it can be manipulated and made to become what we want it to be. Instead of the computer screen, the traditional photographer has the darkroom, where all kinds of miracles can be performed. The rediscovery of ancient toning methods and half forgotten early printing processes has provided an extra dimension, and allowed photographers to produce pictures that wouldn't look out of place in an art gallery. As a bonus, many toners will also give a print a life expectancy of well over a hundred years as well, provided that the ground rules for display are followed.

A glance through the images in this book will show that black and white, thanks to these toning methods, can be surprisingly colourful at times, and equally impressive is quite how effective the final results can be. This is photography proudly proclaiming its history and heritage, and establishing a niche for itself that technological progress in the world of imaging won't erode.

The future of black and white looks secure, and its following will continue to grow as more and more photographers discover its advantages. So, listen to what the photographers in this book have got to say, pick up your camera and get out there and find out what black and white can offer for yourself. You won't be disappointed.

Terry Hope

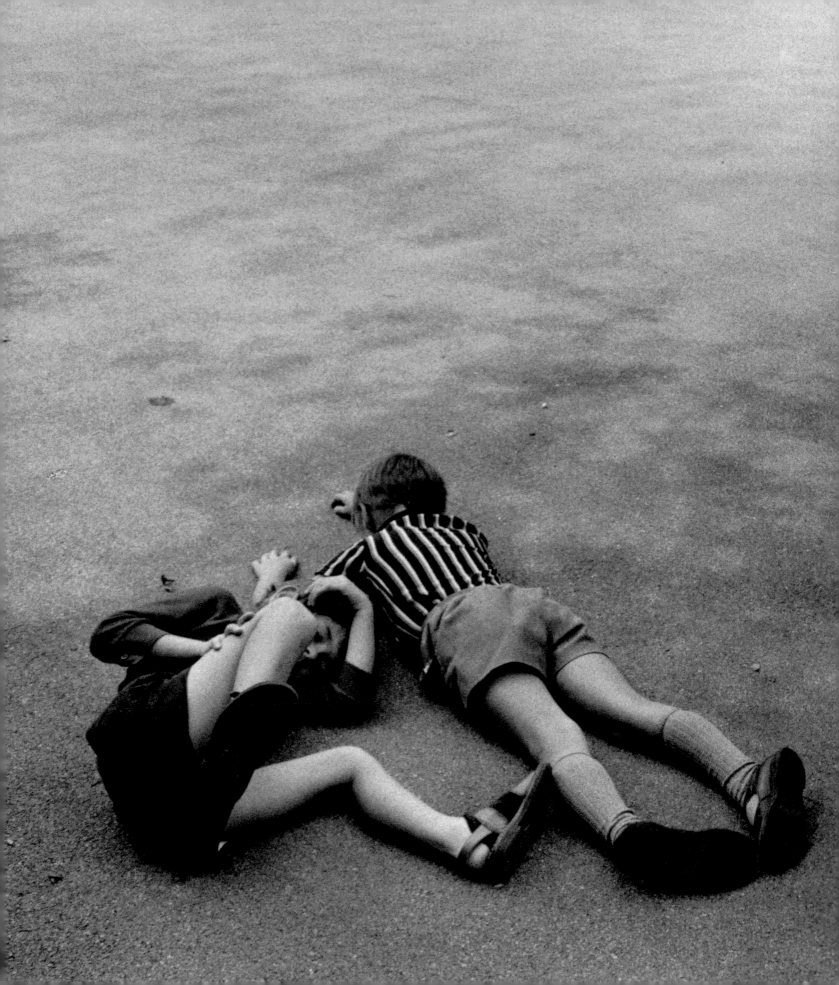

12 Composition
28 The Decisive Moment
48 The Photo Essay
66 Portraiture
90 Gallery
104 Tone, Texture and Contrast
118 Printing and Processing
128 Finishing, Exhibitions and Websites
136 Biographies
142 Glossary

Composition

Composition is one of the most classic of the photographic arts. There are numerous rules that can be followed but, as this section makes clear, most are there to be broken. The best photographers develop the art of composing through sheer instinct – put simply, if it looks right, that's all that matters

Man Fishing at North Shields by Gary Wilson
Canon F1, 24mm lens, Kodak Tri-X film.
Exposure 1/30sec at f/4

Composition

Technique Shooting in foggy conditions is similar in some ways to shooting in heavy rain or in snow, in that it's very easy for the meter to be fooled by so much of the same tone into indicating the wrong exposure. I was aware that this might be a problem and so, after determining that I wanted to achieve a silhouette while still retaining some detail in the quayside, I decided to take a straight reading and then to overexpose by around half a stop.

Printing and Processing This wasn't a particularly difficult image to print and most of it was produced with a single exposure of 16 seconds on grade four paper, a hard grade that had been chosen to try to add some contrast into what was a very flat scene. The sun in the top left of the picture was too bright, however and that part of the picture was burning out. To overcome this I gave this detail a further 16 seconds of exposure, keeping my dodging tool moving at all times to ensure that there were no hard lines between this and the rest of the image.

I was working on a personal project to photograph the declining fishing industry in the north east of England and, as part of this, I had spent time at several different ports in the area. This image, however, saw me going off at a little bit of a tangent, although I still felt that it had something to say within the series. This shows someone fishing in the old fashioned way off the quayside in North Shields early one bitterly cold morning, when the tide was low and the fishing boats themselves — apart from one mast visible just to the right of the figure — were largely hidden beneath the sea wall.

This suited me, however, because the appeal to me was the sheer emptiness of the scene, even though I knew that it had been taken in a location that, at other times, was totally full of life. Composed this way it's almost a picture of nothing: there's just the little silhouette of the figure, the diagonal of the quayside and the sun trying to burn its way through heavy fog, which has limited visibility to around 20 feet or so.

Sometimes it's what you leave out of a picture that gives it its impact and this, to me, spoke volumes about the area and the conditions that the fishermen so often face in their working lives.

Gary Wilson

"Sometimes it's what you leave out of a picture that gives it its impact."

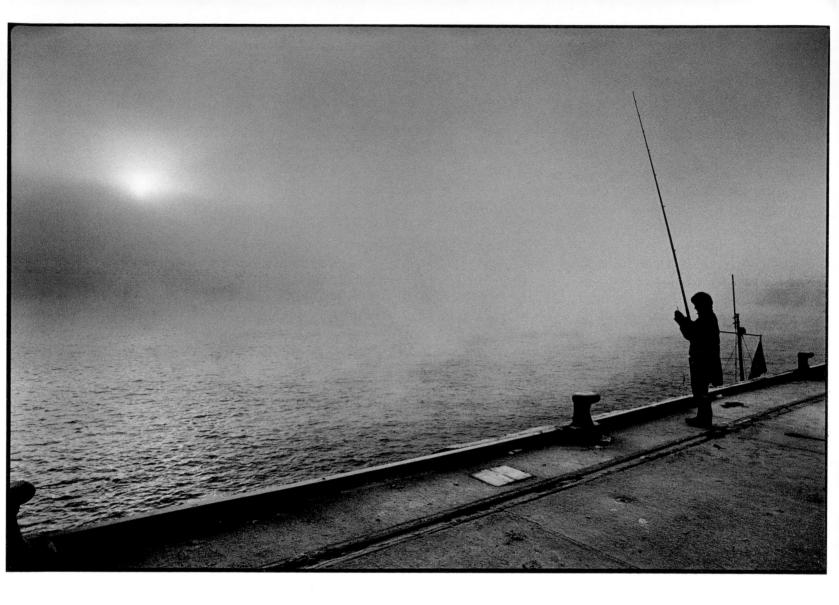

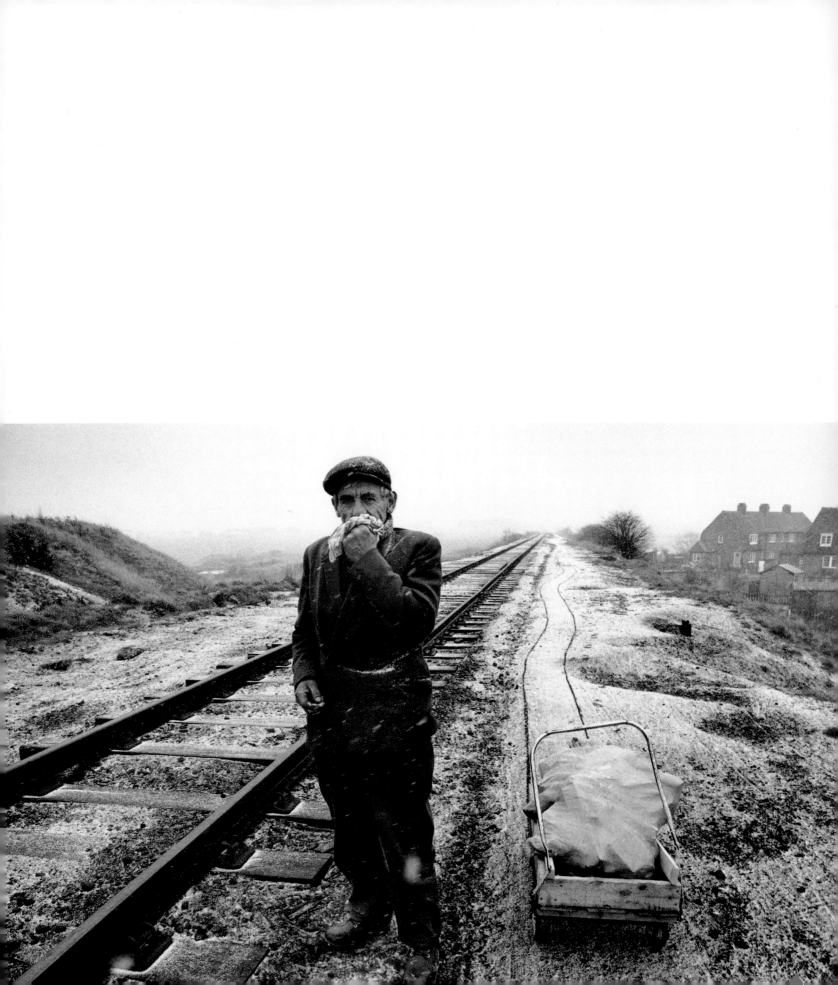

Composition

Railway lines leading into the distance creates a strong diagonal, which adds drama to the composition

Unemployed Miner by Bryn Campbell
Nikon F, 28mm lens, Kodak Tri-X film. Exposure not recorded

I was on assignment for **New Society** magazine in the north east of England in the early 1970s, during a period when I was taking a lot of pictures depicting social conditions at the time. This picture was taken near Easington Colliery and features an unemployed miner that I met, who had been to the rubbish tip nearby to hunt for firewood.

For me as a photographer the snow was a huge bonus, because it allowed me to show the track that the cart he was pulling had made, and the lines created a link between the foreground middle distance and background. I used a 28mm lens to make my picture and composed very carefully, moving the man just off-centre and allowing the railway track to also act as another device to take the eye through the picture.

The 28mm is as wide as I like to go through choice, simply because I'm keen to avoid introducing distortion into the picture. It is possible to work with a 24mm successfully, but you have to be much more careful and, when you're faced with just a few short moments to get your shot, you will find that you have very little room for error.

Making a picture of this kind, I always try to compose for the whole frame, and everything here is important and I've worked to achieve a good balance. Subsequently cropping the image, even slightly, would upset the relationship that exists within the frame and would take away some of its strength.

Bryn Campbell

My Favourite Tip After I met this man and asked his permission to take some pictures we started talking and I mentally lined up all the elements in the scene. Once I had done this I waited and watched his movements. When he put his handkerchief to his mouth at one point I realised that this was the image I wanted and that was when I pressed the shutter.

Pointer I always make a point of trying, where possible, to supply a print to someone who has agreed to pose for a picture for me. In this case I took this man's address and duly sent him a print a few weeks later. Shortly afterwards I heard from the man's daughter that he had died — he had obviously been very ill when I photographed him — and she thanked me very much for my picture and sent me a postal order to cover its cost. Obviously it wasn't my intention to charge for the print and I was very moved by that gesture: it was such a kind and thoughtful act by the man's family, especially when it was likely that they could ill afford it.

Woman and Arrows by David Gibson
Nikon FM2, 50mm lens, Ilford XP2 film.
Exposure 1/60sec at f/5.6

Composition

There are often common themes running through the pictures I take. One is an interest in arrows, particularly those that are used on the roads to indicate traffic direction, because I'm fascinated by bold graphics such as this. I like to take a high vantage point, such as an overhead walkway, and to look down on them from above so that they become a profound background as things happen around them.

This particular image was taken close to Waterloo Station and I framed tightly and arranged the arrows as I wanted them in the frame, leading the eye to the top corner of the picture. Then it was a matter of waiting for the right person to walk into the view. The position they were in was crucial to the overall composition: I pressed my shutter just before this woman reached the convergence of several sets of lines, so that it is clear she is still walking towards it and there's a hint of expectation.

Sometimes pictures work and sometimes they don't and I don't wait long for things to happen, moving on to my next picture quite quickly if I sense that things aren't going to work out. This image was successful because it's so simple and uncluttered. If there had been more than one figure in view then it wouldn't have worked nearly as well.

David Gibson

Pointer This is a quiet picture and I didn't realise when I took it how successful it would be. It's been used countless times by publishers because it has a narrative and, as such, it can illustrate a number of visual points that people want to make. I wouldn't myself say that it was in the usual sense of the word a great photograph but I've earned more money in reproduction fees from this image than any other that I've taken.

My Favourite Tip It pays to identify themes in your work, because this can serve as an inspiration to you and can suggest ways in which you can move your photography forwards. Along with arrows I've also had a long-term personal project which involves looking at words as they appear in the street on posters or notices and then relating them to people around them (see Gallery). I never like to pose anything, rather I spot the potential of a scene and then wait for a period to see what will develop.

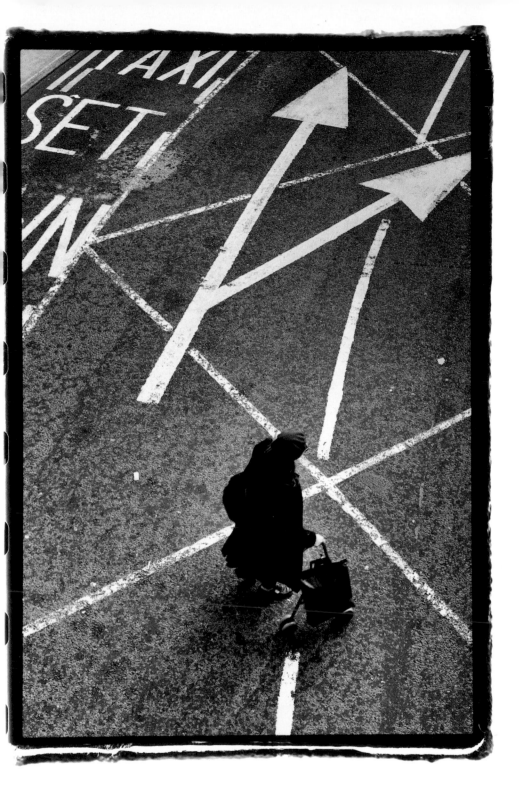

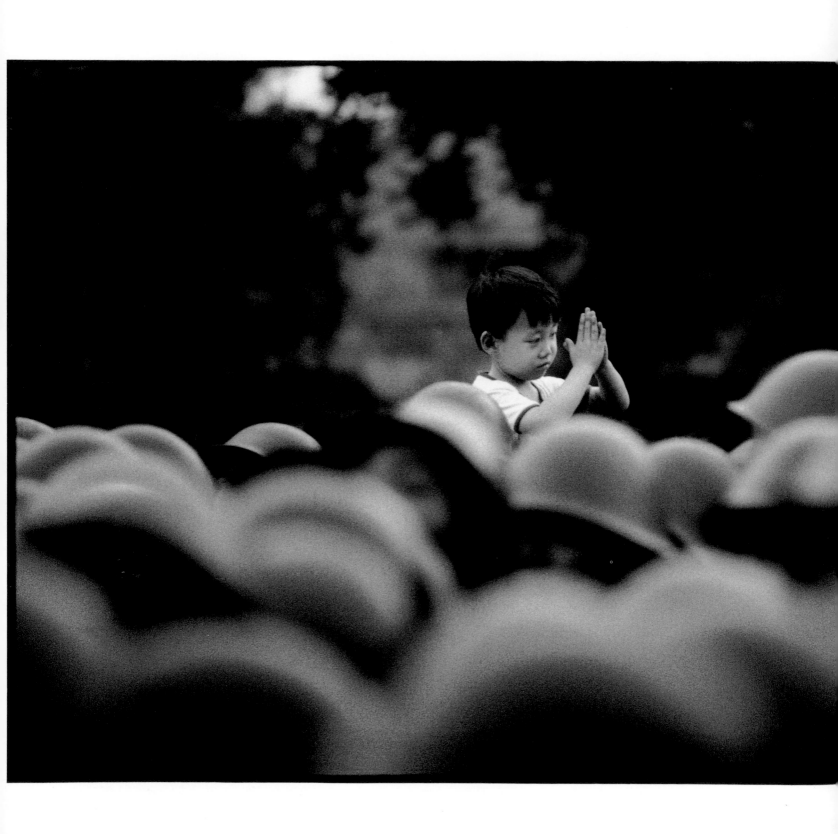

Composition

Tiananmen Square by Dario Mitidieri
Nikon FM2, long end of an 80-200mm zoom, Kodak Tri-X film.
Exposure 1/125sec at f/2.8

I took this picture in Tiananmen Square, Peking, on the afternoon of June 3, 1989 and the massacre took place there later that evening, giving greater poignancy to this image of a young boy welcoming the troops as they arrived. It was a one of those rare moments when you know immediately as you press the shutter that you've achieved a picture that is special and yet so many of the circumstances that I was faced with at that time were imposed upon me.

For a start I was confined to one position and was actually standing on a bicycle to gain height so that I could see across the top of the troops. The only way that I could make the boy a reasonable size in the frame was to use the 200mm end of my telephoto zoom, which meant that I had to set a minimum of a 1/125sec shutter speed to allow me to hand hold with some degree of certainty. This in turn ensured that my f-stop had to be the maximum aperture of f/2.8.

Even so, it was one of those occasions where everything just worked out. The narrow depth of field that I was forced to work with made sure that the boy was the only thing in focus in the whole frame, while the helmets of the troops in front of him, while blurred, are still recognisable and act as a threatening foreground. Behind the boy the softness of the background ensures that nothing takes away from the power of his pose, while his central position in the frame allowed him to achieve maximum impact.

Dario Mitidieri

Pointer As a photojournalist sometimes you have to follow your instincts. The stand off in Tiananmen Square had been going on for several weeks and many photographers and reporters had left believing that the situation was quietening down. I was one of the few who thought otherwise and had arranged to spend ten days in the square to see what would happen. As things worked out my flight home was booked for the afternoon of June 4 and, when I arrived back in London, I had with me the first original pictures to come back from this momentous event.

Portraits The use of areas of focus and blur is an effective way of isolating characters from a crowd or a distracting background. A SLR, especially one that offers a stop down facility, will enable you to see in your viewfinder exactly the effect that you'll achieve. The greatest impact comes when working with the aperture fully open while standing relatively close to a subject, so that areas of blur will appear both in front of and behind them.

"It was a one of those rare moments when you know immediately as you press the shutter that you've achieved a picture that is special."

I was on assignment for the Save the Children Fund in a remote part of Kenya when I came across these villagers, and I was struck immediately by the beautiful and intricate jewellery that they were wearing.

As a straight picture something was lacking, so I decided to move in close and to add drama to the picture through the composition. I like the result a lot: the composition is so up and down and there's a feeling of elements coming in and out of the frame. It gives a new dimension to the picture, which I think makes it stronger.

The main point of focus is on the mother and her child, but I've arranged the picture so that she is in the corner of the frame and here, I feel, she's still allowed to dominate the scene, even though a more traditional approach would have been, perhaps, to place her more centrally.

It was a very natural viewpoint for me to take up. I compose quickly and by instinct, not by the rule book, and know immediately when I look through the viewfinder whether or not something is going to work for me on film.

Dario Mitidieri

Pointer This was a very vivid scene and I did take some colour pictures here as well. The colour worked well, but has more of a National Geographic feel to it, which wasn't really what I wanted to achieve. I think the use of black and white has taken away some of the distractions that colour can add in a situation such as this, and has allowed more of the personality of the subjects to come through.

Tone and Texture The intricate nature of the beads around the necks of these women has been rendered in great detail by black and white film and, as such, they have become an important design element within the picture. By paring down the information that the viewer is presented with, black and white will actually concentrate attention more on the tones and textures within a scene and will heighten their impact.

Composition

Kenya by Dario Mitidieri
Nikon F4, 35mm lens, Kodak Tri-X film.
Exposure 1/125sec at f/5.6

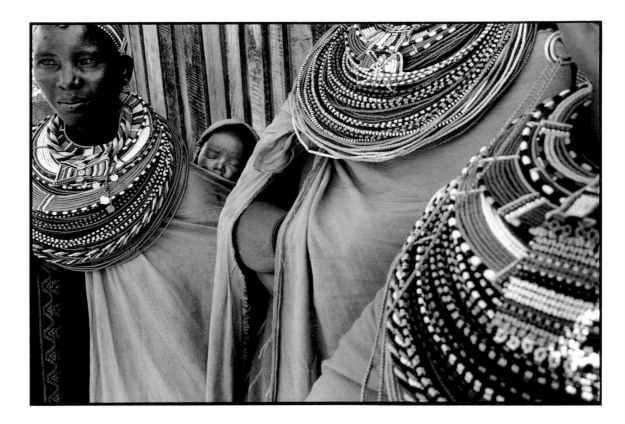

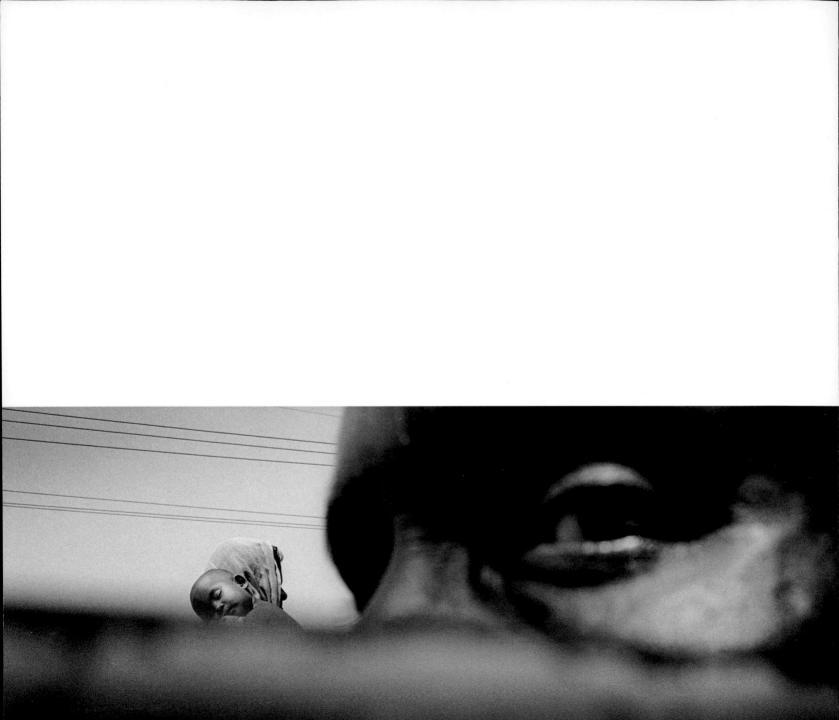

Composition

Burmese refugees in Bangladesh by Dario Mitidieri
Leica M6, 35mm lens, Kodak Tri-X film.
Exposure 1/250sec at f/16

I was working on a story about repatriation and, as part of that assignment, was photographing Burmese refugees who were about to be sent back home from their temporary camp in Bangladesh. Some were being loaded on to a truck to be taken to boats and I decided to make some pictures while this was happening. That was when I saw this image: by moving in close to the side of the truck that this man was sitting in — probably no more than a foot — I was able to throw it out of focus and to use its tone as a strong element of the composition. Meanwhile by setting the aperture to f/16 I retained just enough focus on the man's eye to make it recognisable, while in the background the man's wife and their child can be seen, tying the three of them together in this scene.

I'm never afraid to move in close when I sense that it will help to strengthen the composition of the picture. Had I stepped back so that I could include more of the truck while keeping the focus consistent throughout the picture the result would have been bland and uninteresting. Instead I've created something that has a three-dimensional feel to it. It's a very unsettling image and one of my favourites from all of the pictures I have ever taken.

Dario Mitidieri

My Favourite Tip If things are looking a little too ordinary, see if it's possible to make things more dramatic by the viewpoint that you adopt. There's no rule that says everything within a frame has to be in sharp focus and, by moving in close, it's often possible to create telling areas of blur within the frame that will add depth to the image. For me the effect is far preferable to the distortion created by very wide lenses, such as a 20mm.

Tone and Texture In a scene that was devoid of strong contrasts, Dario Mitidieri has created his own by allowing an area of shadow on the side of the truck to become a dominant slab of dark tone across the bottom of the image. It's allowed attention to be focused on the three subjects, and has emphasised their importance within the frame.

Composition

Sudan Famine by Tom Stoddart
Leica M6, 35mm lens, Ilford HP5 film.
Exposure 1/250sec at f/11

For me it's as important to what to leave out of a picture as it is to know what to keep in. It's a question of framing in the camera: for this picture of a Dinka woman and her children, which was taken at one of the aid camps during the famine in Sudan, I decided that it wasn't necessary to show the faces of the children themselves. The woman's face is where the power of the picture comes from and you look at it and you see how much pain this beautiful and dignified person is suffering. There are enough other details included, particularly the matchstick thin legs of the boy on the left of the picture, to tell the viewer what is going on and some things don't have to be spelt out in too much detail.

When taking a picture like this you have to move in quickly and decide where you want the viewer to look. People can move and so you have very little time to decide what you want to do and invariably you have to act by instinct and to grab the picture in a split second.

Tom Stoddart

Technique The light here really worked for me, because it was bouncing off an adjacent white tent and was being thrown across the woman's face, giving an amazing quality and texture to her skin. Those who are looking to become photojournalists have to learn to observe natural light and to see what it's doing and then, if they can, to utilise this in their work. Sometimes by just moving a foot or two in a particular direction an ordinary situation can be transformed into something special.

Pointer When starting out as a photojournalist you have to learn to react quickly to a scene. It's a good idea to take a wide-angle view of something with your eyes and then to mentally strip away the things that are not strictly necessary. What you're left with are the most effective elements and these are what you should try to capture on film.

Picture Tom Stoddart/IPG

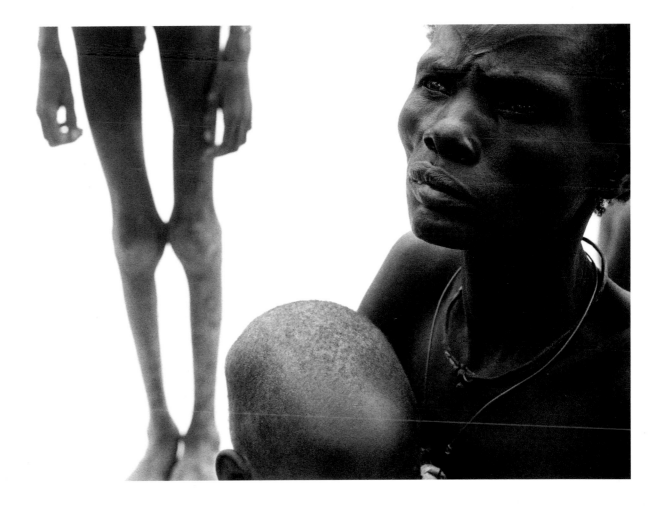

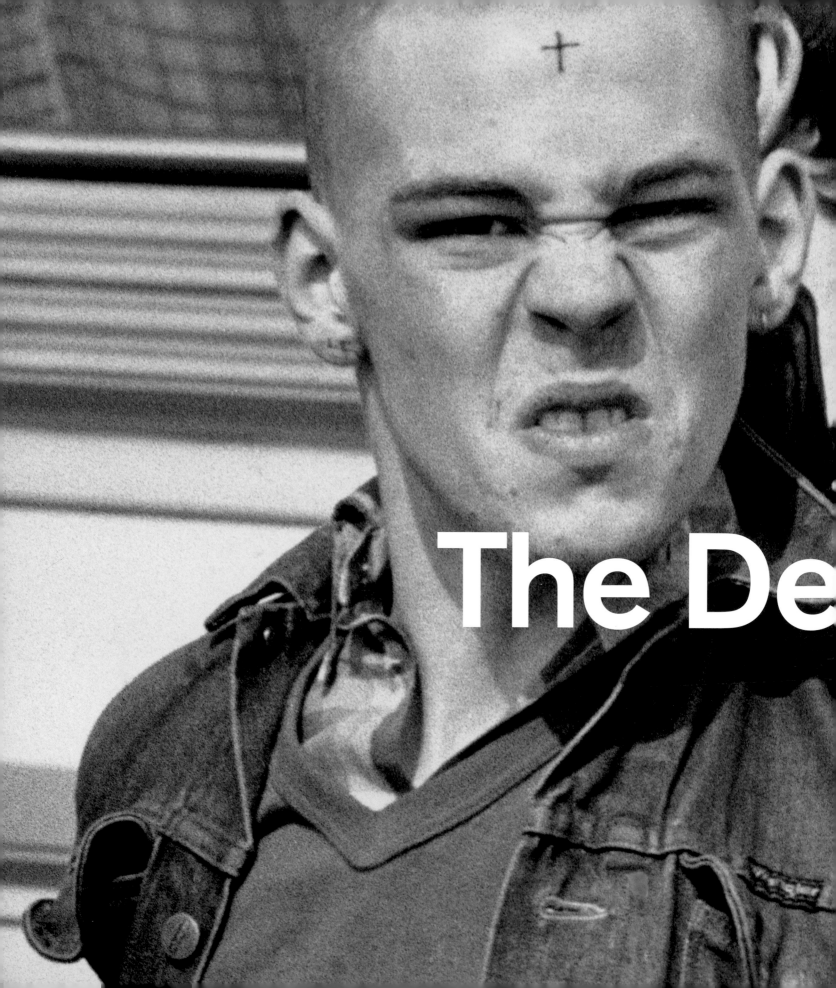

The De

cisive Moment

The art of the photojournalist is most truly revealed in the ability to catch the moment on film that reveals the essence of a situation, creating a far more powerful statement than can ever be provided by moving imagery

This child, Savita, was just two and a half years old and was part of an act that was being performed for the crowds in Bombay. It was an incredible thing to see and I knew that it would make a strong photograph, but it was important for me to isolate the little girl from what was a very distracting background.

The only way that I could achieve this was to fit a 300mm lens and to take up a position where I was looking up at her so that she was seen against the white of the sky. The small amount of blurred detail behind her that is visible at the bottom of the frame helped to place her within the scene and was important to the composition.

I took the picture at the moment when Savita raised her arm during the act, but the real drama of the scene was unseen by me at the time. The fact that the pole is being balanced on just the thumb is something that I only realised when I was looking through the contact prints at a later time. People get a reaction when they see the picture for the first time and notice that detail: I got that same reaction myself when I saw what I had achieved on that negative.

Dario Mitidieri

Savita, Bombay by Dario Mitidieri
Nikon F4, 300mm lens, Kodak Tri-X film.
Exposure 1/500sec at f/5.6

Composition I was aware that I would have this picture printed with strong black borders and so I positioned Savita directly in the middle of the picture so that the line of the pole would be parallel to the edges of the print, allowing a perfect symmetry to be created. The fact that the background is so plain worked with the composition to make this a very graphic image.

Pointer When you see a situation that you know has the potential for a strong picture, take a moment to decide the best approach. Different lenses allow alternative approaches to be taken and will give you more options. Take particular care to look behind and around your subject to ensure that nothing is included that will prove distracting.

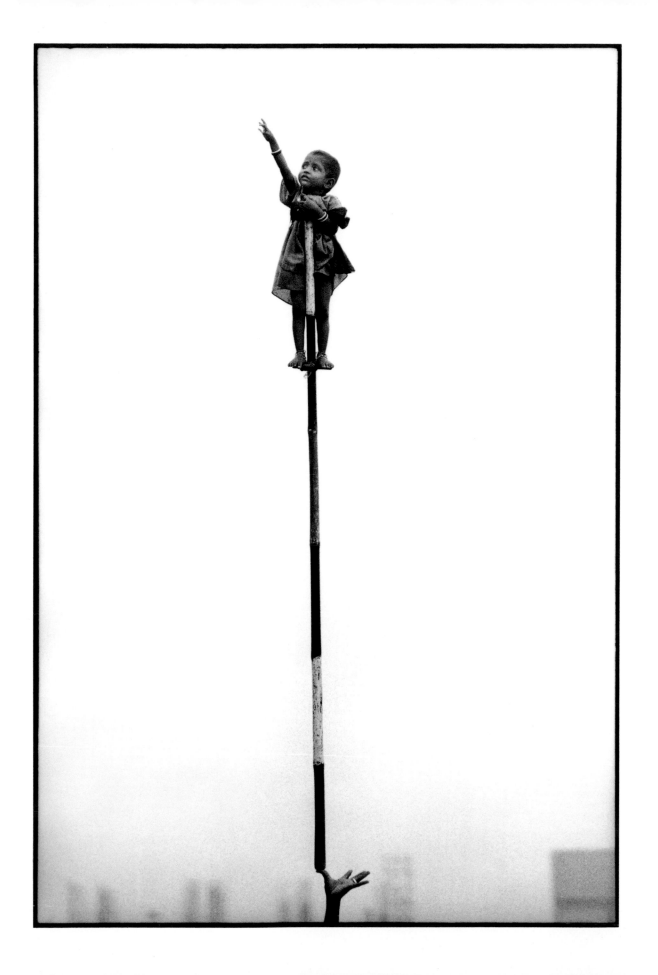

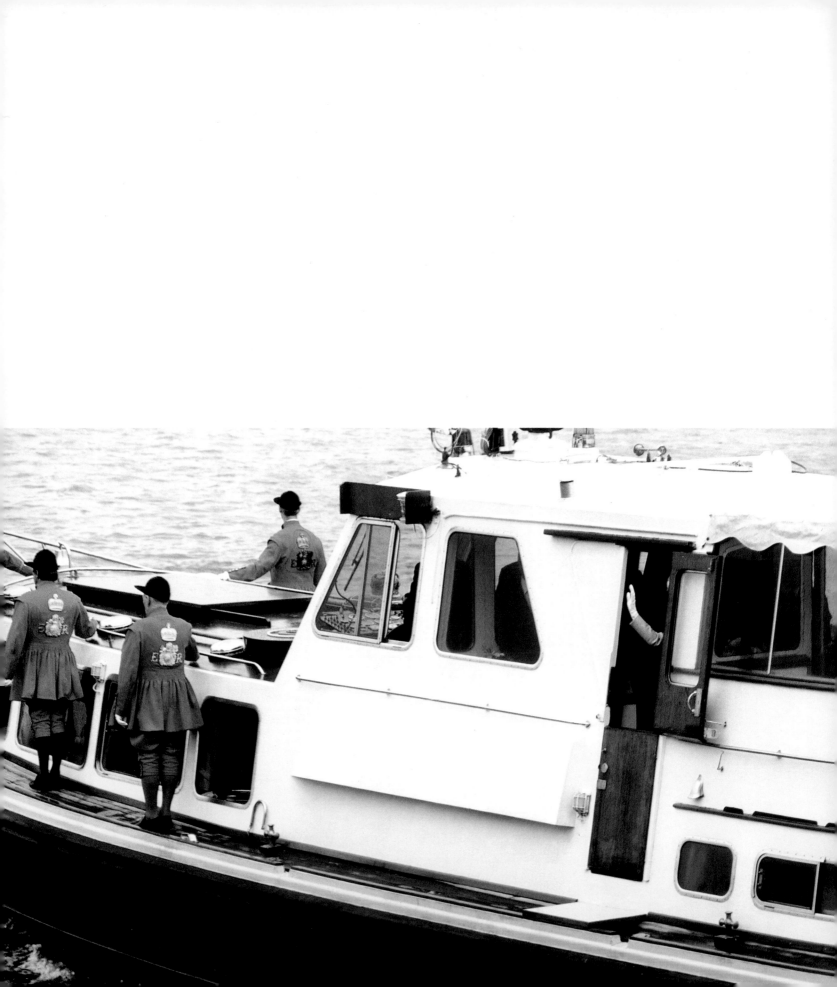

The Queen in Silver Jubilee Week by Bryn Campbell
Nikon F, 400mm lens, Kodak Ektachrome 160 printed as black and white.
Exposure 1/500sec at f/5.6

"The focal point of the whole image is the white glove against an area of black background, and that's the area that I focused on. "

I've always disliked clichés and I try very hard to avoid them. Whenever I get the chance to take something a little more subtle, perhaps even a little too subtle for the publication that the pictures might be destined for, I will always go for it. It's just in my nature and I think you can get some much more interesting images this way.

On this particular shoot I was one of a team of photographers that had been commissioned to cover the weeks surrounding The Queen's Silver Jubilee in 1977 for **The Sunday Times Colour Supplement**. The Queen was undertaking a lot of visits around London in that period and was using the royal launch quite regularly and, on this occasion, I just happened to see the potential of this situation from a position on the riverbank and decided to produce a very unusual portrait.

To my mind the picture works — even after it was printed as black and white from its original colour — because the focal point of the whole image is the white glove against an area of black background, and that's the area that I focused on.

I knew that I had to crop in on the boat to make the hand large enough in the frame to be effective. I also realised, however, that if I included the backs of the courtiers with their royal crests in the frame then the viewer would be given enough visual clues to work out who this was waving to her subjects.

In the end I got more than my share of images included in the supplement but this wasn't one of them. I think it may have been just a little too oblique, but that, I feel, is where its charm lies.

Bryn Campbell

Technique I needed to use a long lens to allow me to frame this picture the way that I wanted it from the riverbank but I also wanted the flexibility of hand holding. The 400mm Novoflex that I fitted was designed so that it contained a built-in pistol grip, which helped me to keep it steady and then I shot wide open and set the fastest shutter speed that I could – 1/500sec – to give me the best chance of achieving sharp results.

Pointer Although this picture is of a high profile event it was taken from a public area that didn't require press accreditation. If the photographer has an eye for an off-beat moment and is prepared to shoot from the middle of what might be quite a lively crowd then the opportunity is there to produce something original even without the benefit of a privileged position.

Skinhead arrested at Southend by John Downing
Nikon F3, 85-150mm zoom, Ilford HP4 film.
Exposure 1/250sec at f/11

It was a bank holiday weekend and myself and Tom Smith, another photographer from **The Daily Express**, had been sent to the seaside resort of Southend because skinheads had been causing trouble there and it was expected that there could be further incidents. We had spent most of the afternoon looking for pictures and I was quite pleased with the overall coverage that I had got but, as we walked along the prom, things had quietened down and we were thinking about heading home.

Suddenly from an amusement arcade came a policeman dragging a skinhead who had obviously just been arrested. As he passed me I lifted my camera and prepared to take a picture and at that moment he turned and snarled at me and made this gesture.

I took the picture instinctively, knowing that, in these pre-autofocus days, I had pre-focused my camera to the appropriate point and could just point and shoot. Looking at my contact strip, this is the only frame where everything comes together. The next frame shows him from behind being led away, and that image clearly shows that he has been handcuffed.

It was an image that caught people's imagination and the picture has been used in many forms – some of them with permission others, such as T-Shirts, without – but it was interesting to hear later from the policeman involved and to see how the incident had developed. The skinhead apparently, when he was away from his mates and had calmed down, had turned out to be nothing like as aggressive as he appeared. The two had got talking and it emerged that they were both the same age: it just struck me as interesting, that both had reached the same point in their lives and had taken very different directions.

John Downing

Technique I was a very early user of zoom lenses and have always found them to be perfectly suited to photo journalism. They allowed me to frame so precisely that I didn't waste any negative space and that ensured that it was more difficult for anyone subsequently to crop my pictures badly. Some photographers avoided zooms initially because of fears about their quality but I've blown some of my negatives up to 20x16in in size and have never had any problems.

Pointer This picture was taken in the early 1980s, well before laptops made the process of wiring pictures back to the office so straightforward. We wanted to get the film back to the Express that evening so that the newspaper had the option to run them in the following day's issue and we were considering how to do this when we saw a motorcyclist who was obviously visiting the resort for the day. With a cash payment there and then and the promise of the rest when he reached the newspaper's office in London we got our film back in record time and as a joke even included a stick of rock for the picture editor in the same package!

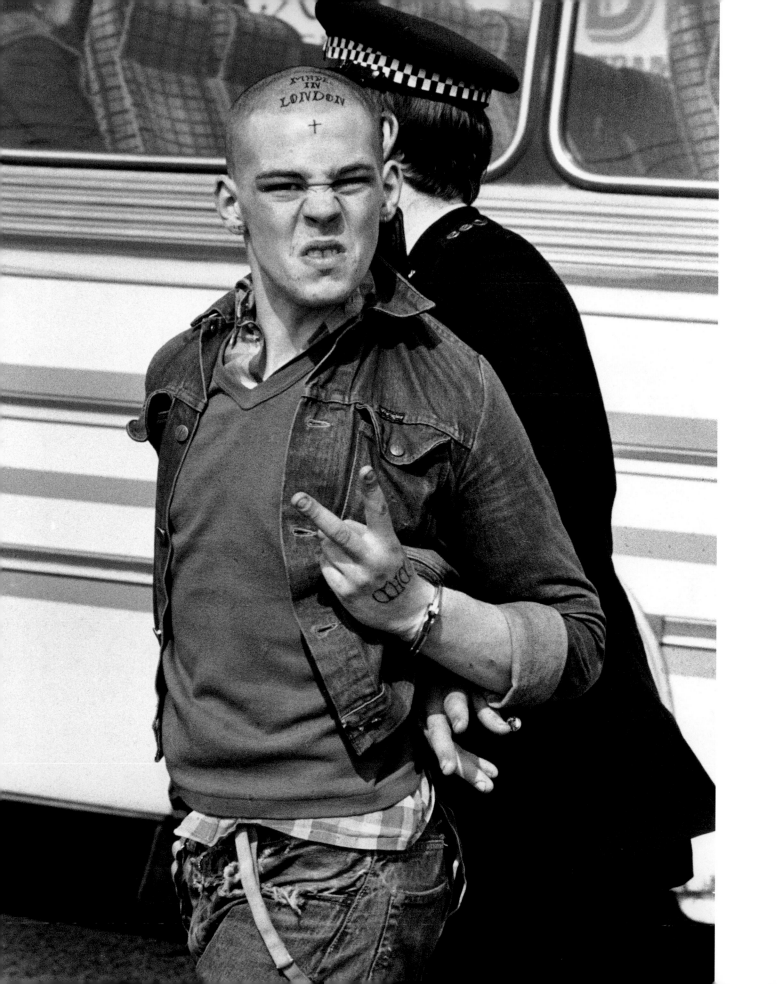

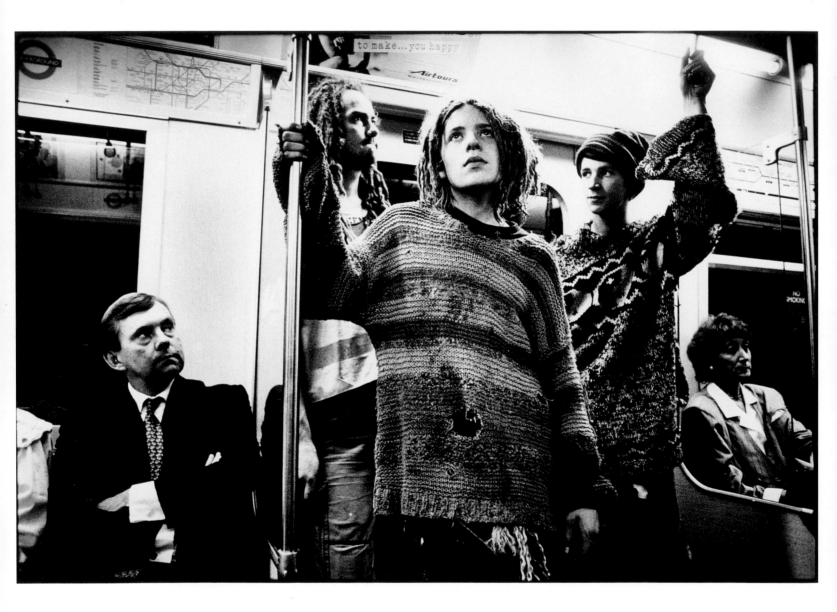

The Decisive Moment

"I knew that this group was a little out of place amongst their fellow passengers and was likely to attract attention."

My Favourite Tip I took this with a 28mm lens, which is wider than I would normally choose to use. My regular lens is a 35mm, which I use for the majority of the time, but in this situation I simply couldn't get back any further and my lens choice was effectively made for me. The only other lens that I use regularly is a 50mm and I find that these three together cover most situations that I'm likely to encounter.

Pointer Many of those planning to take up photo journalism imagine that the only stories worth covering are those on the other side of the globe. In fact many worthwhile projects can be found much closer to home, as David Modell has proved here. It's a case of looking for a subject that has potential and then working hard to get under its skin and to win the trust of those who you want to photograph. Only when you fully understand an issue are you likely to be able to shoot any worthwhile pictures relating to it.

Picture David Modell/IPG

I was doing a series of pictures on road protesters, following a group that was opposing the M11 extension through a suburb of east London. As part of this I found myself travelling into Central London on the tube to attend a demonstration that was taking place there. The tube is one of those places that brings disparate people together and I knew that this group was a little out of place amongst their fellow passengers and was likely to attract attention.

It was just one of those times where you look beyond the immediate subject and try to anticipate what is likely to happen.

I like situations like this, where you're waiting for people's responses to things. There was the contrast of this group standing next to other people who were more conventionally dressed and I knew something would happen, even if only for a moment. It was just a question of waiting for the look and then being quick enough to catch it on film.

David Modell

Eco Warriers Travelling to a London Demonstration by David Modell
Canon EOS 1, 28mm lens, Kodak Tri-X film uprated one stop to ISO 800.
Exposure 1/30sec at f/2.8

Burmese Refugees in Bangladesh by Dario Mitidieri
Nikon F4, 35mm lens, Kodak Tri-X fil.
Exposure 1/500sec at f/11

There are times when you see pictures that are complete and waiting to be captured and other times when you see just the potential and will know that there is the chance that something might happen to bring a scene to life.

The latter was the case when I was walking around a refugee camp in Bangladesh that was temporary home to Burmese refugees who were waiting to be repatriated. The camp wasn't very photogenic and I was looking for ways to produce interesting and effective pictures when I noticed this fence with holes through it and realised that a woman was watching me through one of the gaps. As it stood it wasn't a great image, but I realised that if I went and photographed the scene then it was likely that the children would be interested and would join in. That was exactly what happened and, as the children went behind the fence and began to peer at me the picture built up and became much more worthwhile.

Eventually this was the moment where it all worked, with the faces at the bottom of the fence offset by the eyes that are visible through the hole at the top. Technically the picture wasn't difficult to take, but it just needed to be spotted and encouraged.

Dario Mitidieri

Pointer It's so easy to miss pictures because you haven't anticipated where a situation is leading, and that's one of the most important lessons for a photojournalist to learn. There is a difference between seeing potential and then having the patience to wait for your picture and actual interference in the situation, however. I would never have seen the fence with the holes and asked the children to pose for me. Rather I spotted what was happening and helped to build the situation in a natural way, ultimately being rewarded with this image.

Technique The 35mm lens, as Dario Mitidieri has proved, is one of the most useful optics for any photojournalist. More so than the 50mm, which is the traditional standard lens, it pertains to the kind of viewpoint that the eye itself will offer and, while its angle of view of reasonably wide, it doesn't distort even when a subject is located towards the edge of the frame. The depth of field the lens offers, even at maximum aperture, is another plus point, ensuring that focusing is less critical.

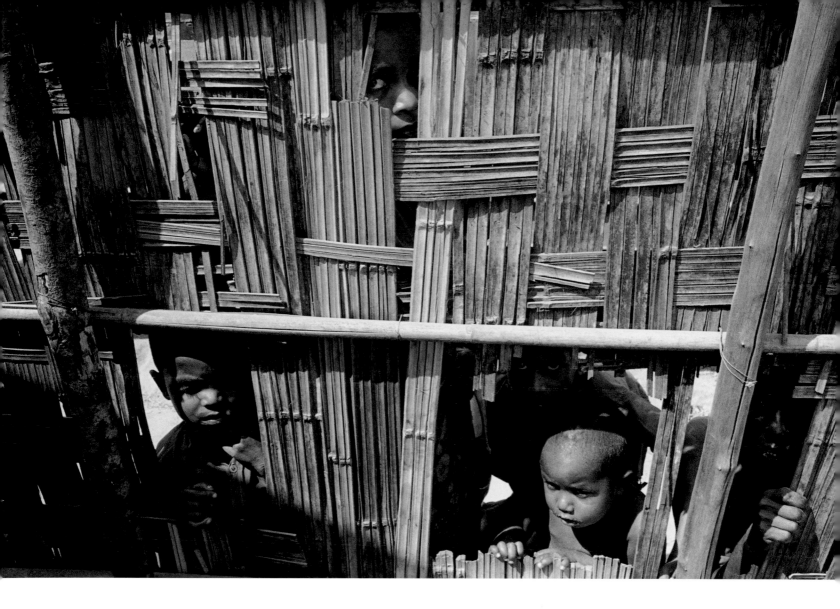

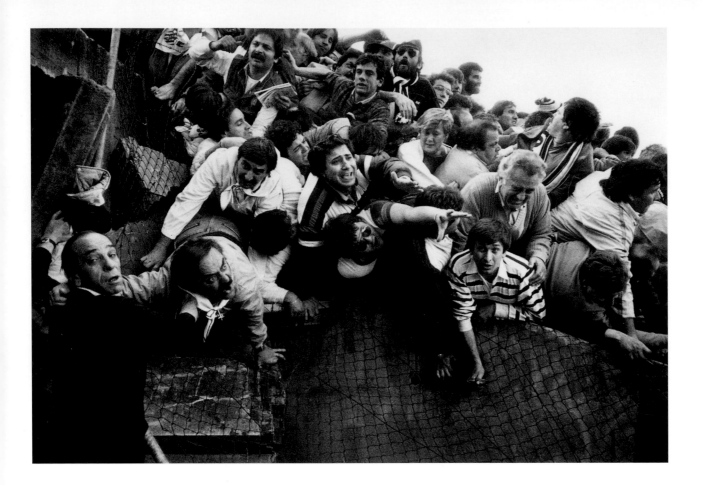

I was working purely as a sports photographer on the night of the 1985 European and Cup Final between Juventus and Liverpool and, as usual, had taken with me my long lenses to capture the football action. Some time before the match started I was aware that trouble was breaking out and, as I watched, I could see a red wave as the Liverpool fans pushed across from side of the stadium to the other.

Assuming that it was the kind of sporadic trouble that often, at that time, marked football matches but which usually died down once the match started, I decided nevertheless to make my way up to the area where the trouble was happening just in case there was anything there that I needed to cover.

As I arrived there was a commotion going on and then the wall in front of me collapsed, throwing people over. I had a Nikon compact camera with me and just pulled this out and took a couple of quick pictures. It was clear that something terrible was happening and ultimately some 41 Italian and Belgian football fans were killed in the crush that night. What I took was, in effect, a picture that was symbolic of the incident: most of those in this picture got out alive, the ones who perished being trampled underfoot by terrified fans further up the terraces.

I was working for a Sunday paper and so was under no pressure to rush my pictures back to the office from what was a Wednesday night game. The daily newspaper scene has changed completely and a picture like this would almost certainly have made the next day's editions now, but at that time the more obvious pictures of the dead and dying were the ones that everyone ended up using.

Remarkably the game itself was eventually played and I went through the motions, shooting three to four rolls of the action. But, like everyone else there that night, my heart wasn't in it and I never had those films processed.

Eamonn McCabe

The Decisive Moment

Fans Being Crushed at Heysel Stadium, 1985 by Eamonn McCabe
Nikon Compact Camera, Kodak Tri-X film.
Exposure not recorded

My Favourite Tip Even as a sports photographer at that time, I was always aware of the need to be prepared for anything to happen. The Nikon compact camera that I had with me was an extra piece of kit that I carried along with my 180mm and 400mm lenses, primarily for the end of game celebrations that took place. This little camera with its built-in flash was useful for helping me to take pictures from close quarters in dark parts of the ground: on this occasion it helped me to react to an incident that was developing in front of my eyes.

Pointer Photo journalists are often criticised for standing back and taking pictures when they might be more usefully helping the people in front of them. All I can do to defend myself is to say that at the time I took this picture no-one had died and I was unaware of how serious the situation was becoming. The fact is that you can't edit the story as you go along, because you're not in full possession of the facts. You just have to follow your instincts and to do your job.

"You can't edit the story as you go along, because you're not in full possession of the facts. You just have to follow your instincts and to do your job."

The Decisive Moment

Back to back houses in Birmingham by Bert Hardy
Rolleiflex 6x6cm camera, fixed 75mm lens.
Film and exposure not recorded

Renowned Picture Post photographer Bert Hardy had the happy knack of producing memorable images from the most everyday of situations and much of that was down to his sense of timing and anticipation of the actions of his subjects.

Here the story he was asked to cover could not, on the face of it, have been more ordinary. The date was 1954 and in gloomy post-war Britain there were huge areas of urban deprivation, consisting of slum housing and little in the way of amenities. Bert's job on this occasion was to show the 'Best and the Worst' aspects of a number of locations and Birmingham was his latest port of call. Typically, although the run down state of the back to back houses was considered one of the downsides of the city, Bert took it on himself to show the human side of the situation and his picture is full of the warmth and friendship that often characterised these places.

Still something was needed to lift the scene, however, and Bert realised that the little boy hovering around his mother was the key to the picture. With his Rolleiflex primed and ready to fire he waited for the moment when eye contact was made and then made his exposure. The result is an endearing study of the love and happiness that exists even in less than ideal conditions and, some fifty years later, it still has enormous appeal.

Picture: Bert Hardy/Hulton Getty

Technique Modern autofocus cameras are extremely fast, but there's often still that split-second of delay that can ensure pictures such as this still can't be judged as accurately now as Bert Hardy did back in 1954. His technique — to set focus to a point where anything at close quarters would automatically be in focus — can still be effective today. If you can find what is known as the 'hyperfocal point' in a scene, then you'll be able to obtain maximum depth of field: this is defined as the distance between the lens and the nearest point of acceptably sharp focus when the lens is focused for infinity. When you re-focus to this point, known as the hyperfocal distance, depth of field will extend from half this distance to infinity, the greatest depth of field it's possible to obtain at a given aperture. Don't forget the basic rule that the smaller the aperture the greater the depth of field, which ensures that the more you stop down the closer the hyperfocal distance will be.

Pointer The more you practice your reportage technique, the better you will become at it. A useful exercise is to visit a lively public place, say a bustling market or a rally, and to shoot a roll or two of film on some of the characters you find there. Spend the first hour or so simply observing, and seeing how people are reacting with each other. If you see an interesting face don't be tempted to rush in and snap away: be patient and wait for the moment. The strongest images are rarely down to pure chance, they have to be worked at, and you'll have a lot of failures before you start to achieve success. One further point to note: Bert Hardy used a standard lens for many of his classic pictures. It's still a great lens to use for candid photography, so don't be tempted to fit one that's longer and to shoot from a distance. The best pictures are usually captured close up.

Eye contact between subjects in the picture has established a bond between them

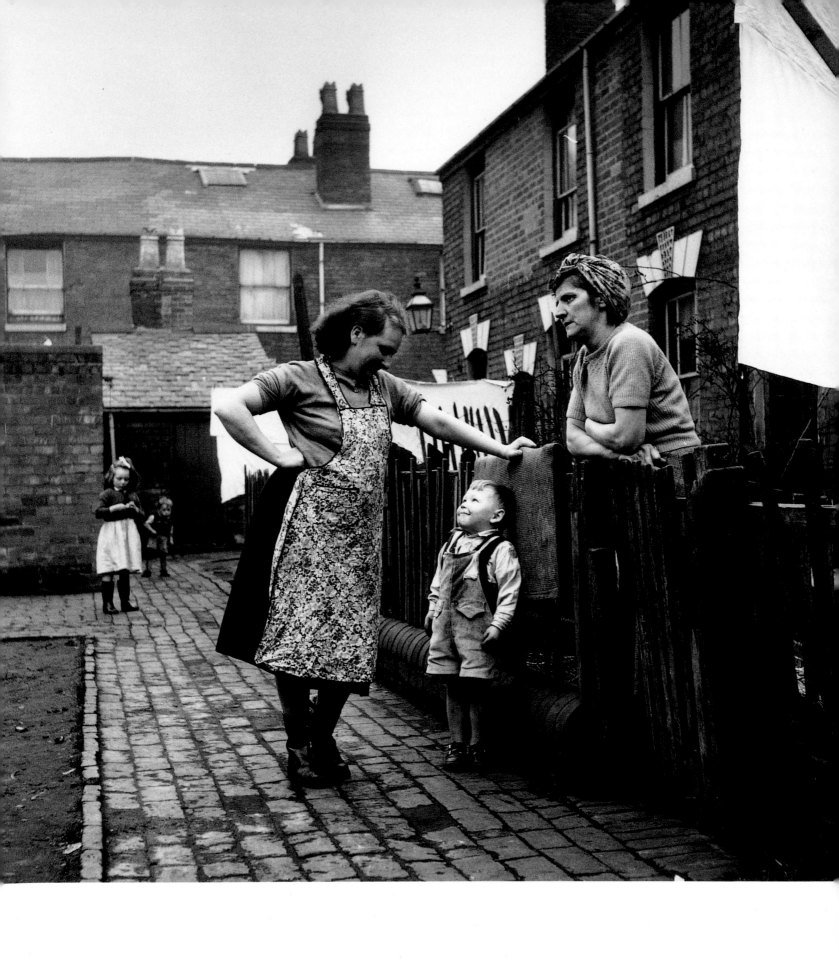

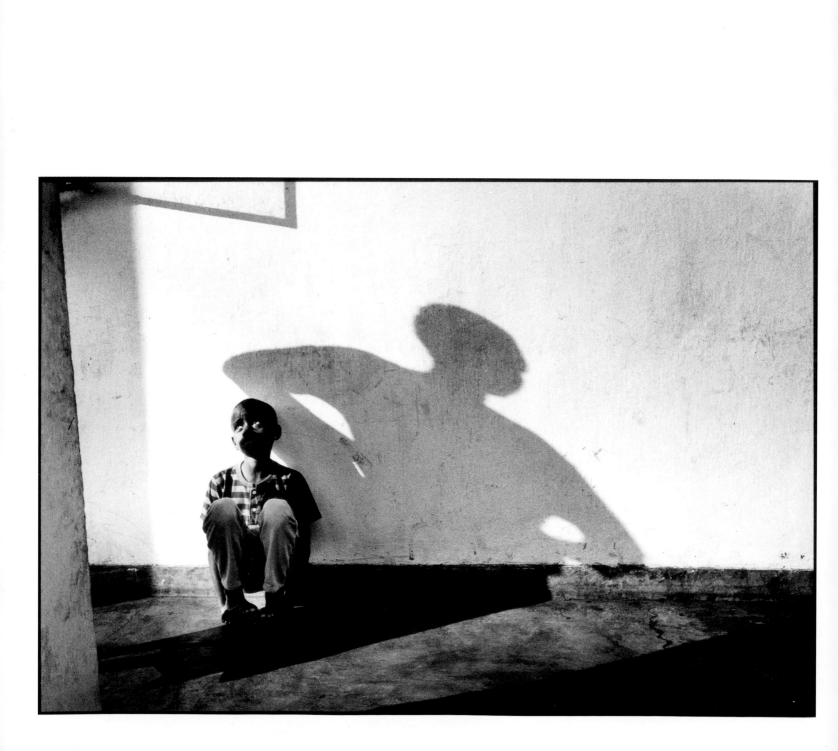

Rwandan Refugee in Zaire by Tom Stoddart
Leica M6, 35mm lens, Kodak Tri-X film.
Exposure 1/250sec at f/8

I came across this little boy in an orphanage in Goma in Zaire, where he had ended up after he was among the one million refugees that had flooded out Rwanda to escape the ferocious fighting that had taken place there. He had obviously been traumatised by what he had seen and this was evident in the look of fear that was still in his eyes.

A lady who has come to feed him is throwing the shadow on the wall behind him and I just saw this scene for a split second and realised what a strong and, in many ways, threatening image it would make. I didn't even really have time to think about the composition or the way that everything was holding together, I just knew that I had to grab a picture before it all disappeared again. The result is a portrait of one of war's more innocent victims, which makes a strong visual point about what these kids have gone through.

The most effective pictures are the ones that are not in your face. This one is more subtle, it has a different way of telling a terrible story. Once again it's the light that has been the key to the image but the main reason that it's worked lies in the eye contact that the child has with the unseen person throwing the shadow. That's crucial and it's given the picture its impact.

Tom Stoddart

My Favourite Tip The Leica M6 rangefinder camera is an incredible tool for any photojournalist to own. Once you've got used to the way that it works you can use it almost by instinct, and this frees you up from all the technical stuff and allows you to witness the scene. It's also really quiet, which can be vital if you don't want to impose yourself too much on your subject. Compared with a noisy motor-driven SLR it's almost silent and that can help you to blend into the background much more easily.

Tone and Texture Observing the light and taking note of the intensity and direction of the shadows that are being thrown can pay huge dividends for photographers who want to achieve pictures that are strikingly different. Here surroundings have also played a part. The impact of the shadow has been emphasised by the light tone of the wall behind the boy, while a darker background would have diluted the shadow's strength and taken away much of the impact.

Picture Tom Stoddart/IPG

There are times when everything comes together in a picture and you realise that you have achieved that elusive decisive moment. I was taking pictures in an aid camp in the Sudan when, right in front of me, a starving boy had his food stolen from him. I took the picture as he looked up at the man who had carried out this terrible deed and in that split second everything worked.

The look of disdain in the his eyes as he stares at his tormentor, the way that his fingers are spread out and the whole shape of his body says so much in this picture. This is the story and it hardly needs any further explaining.

I didn't need to show the whole of the man who had carried out this theft. You see enough to place him and in many ways he's an icon for Africa, the big man with the stick who steals from the underprivileged. As he walks away the transparent nature of the bag he's carrying makes the nature of his crime fully evident and this is the final element in a picture that makes a very powerful point about the brutal nature of famine in this part of the world.

Tom Stoddart

"The look of disdain in the his eyes as he stares at his tormentor, the way that his fingers are spread out and the whole shape of his body says so much in this picture."

Man stealing from starving boy, Sudan by Tom Stoddart
Leica M6, 35mm lens, Kodak Tri-X film.
Exposure 1/250sec at f/11

Pointer Moving pictures will flash in front of your brain for an instant and are then gone but a still image will let you soak up all the detail and will make a far bigger impression. You can even put the picture down and pick it up again at a later date and see something completely different. This is the power the photojournalists have and it's hard to see how new technology could ever dilute that.

The Photo Essay This was one image from a set that I brought back from the Sudan and the pictures, naturally enough, raised the issues that often confront photojournalists, in that some people questioned whether photographers should have been covering such a shocking situation in the first place. In fact I was very moved by the scenes that I had photographed and I came back from the Sudan with pictures that I was determined would change opinions and enlighten people regarding the suffering that was taking place. The Guardian newspaper ran three images, one on the cover and two inside, and inside 24 hours Medecins Sans Frontiers, the charity whose camp I had visited, had received £40,000 in donations, which rose to £150,000 by the end of the week.

I'm proud of that and I think it proves the point that, despite what some term donor fatigue, people will still respond to powerful images, which is why it is so important that they continue to be taken.

Picture Tom Stoddart/IPG

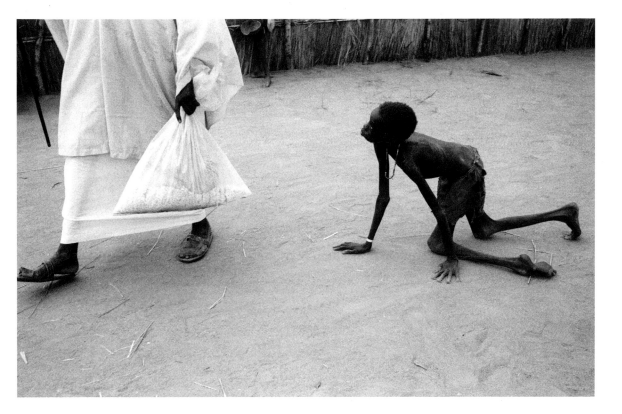

Th

e Photo Essay

The classic photo essay is an established part of photojournalism that allows the photographer to piece together a story through a series of inter-related images, which work with each other to create an in-depth documentary

The AIDs Crisis in Africa by Tom Stoddart
Pictures taken with a mix of Leica M6s and R6s, 28mm, 35mm and 50mm lenses
and a Rolleiflex 6x6cm camera. Ilford HP5 film used throughout

The AIDs crisis in Africa is an absolute catastrophe and yet it's largely been forgotten about or is ignored by the rest of the world. It's unbelievable in many ways: there are something like 6000 people dying a day from this disease and if this was happening in Europe or the US it would be one of the biggest stories of them all. And yet, because it's the third world, everyone seems to have given up on it apart from a few brave aid workers and religious people.

I'm on my second year of covering the story and, to date, have travelled to Kenya, Zimbabwe, Zambia, South Africa, Malawi and Uganda to take pictures. Shooting pictures of AIDs victims is, in many ways a licence to lose money because the story is very unpopular with magazines who seem more concerned to take the celebrity route with their publications, and it's very difficult to get anyone to use my images.

To me, however, that isn't the point. I think the photojournalist has a responsibility to go to situations and to bring back powerful and truthful images that may well help to change things. That's how we can justify ourselves standing there taking pictures while dead and dying people are all around us. I want my pictures to make people think and to educate them, to embarrass politicians who should be ashamed of themselves and to raise money to help fight this disease.

With this project I started off by not knowing much about the disease and its impact but I had seen the work of other photographers and I thought that it looked like something that was worthwhile to do. I tried to research it but there is no substitute for buying the airline ticket and the film and just going, because you learn everything you need really through experience on the ground.

Once I reach a place I contact the aid agencies and religious organisations and have to win their trust so that they will allow me to go in and to cover the work that they are doing. The first thing you have to realise is that these are real people who are ill and you have a duty to get their permission to take pictures and to explain to them what it is that you are doing. Even then you don't have a licence to run around with your camera: when people realise that you are being sensitive and are making pictures that reflect the truth of the situation then you will get more help from them.

Tom Stoddart

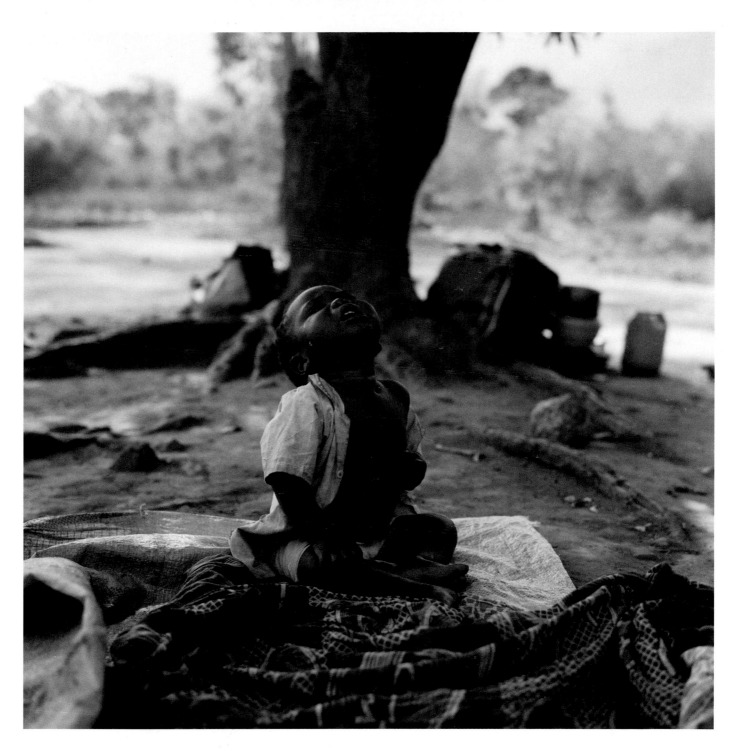

→

"There are something like 6000 people dying a day from this disease and if this was happening in Europe or the US it would be one of the biggest stories of them all."

Technique With all of these pictures and most of those that I shoot on assignments, I use a hand held meter to make sure that my negatives are as well exposed as they can possibly be. This care extends to the treatment of the film at the processing stage. The death of a black and white negative is over development, and so I take great care that my film is well processed. Too many of those who are starting out in photojournalism are in such a rush to see their contact prints that they don't take enough care over this stage of the proceedings and this can impact on the quality of the final print.

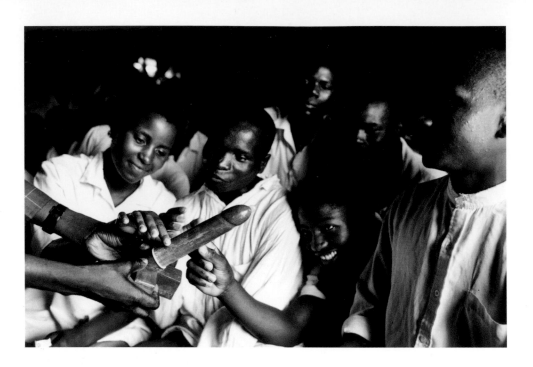

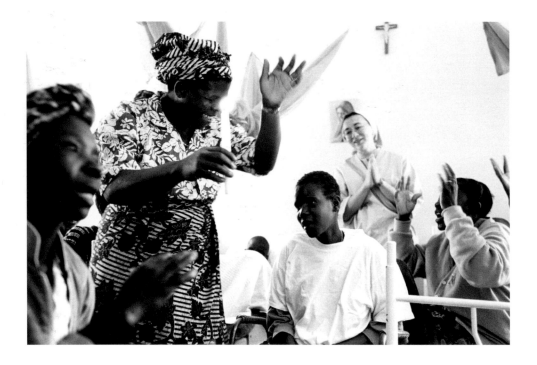

I was living in Paris towards the end of 1983, working with a group of friends in a small photo agency we had set up, and I didn't have anything planned for New Year's Eve. The idea hit me to go out into the streets with my camera to see how people celebrated the Eve of 1984. It was a really good time and I came back with some exciting pictures. At that time I was looking for a personal project to allow for new exploration — such as working with flash — and to help me track my own progress over an extended period. I decided the New Year's Eve idea would be a good subject to explore in depth, so I made a resolution to photograph the celebration from year to year, each time in a different city.

The next year I visited London and photographed the celebrations there, simply walking the streets to see what I came across. The year after that I moved to New York, so I spent that year among the crowds in Times Square. From then on it just snowballed as I began contacting friends and arranging to stay with them in different locations, across the country and around the world. As the project developed its own momentum, my approach to it evolved. By the time I arranged to visit New Orleans, for example, my work had received enough attention to provide me with access to private locations like fancy parties and clubs. I did a lot of advance research to compile a list of venues and I planned an itinerary from that. I wanted to include a range of different social levels and cultural types relevant to the make up of each place so that my coverage gave a flavour of what it was really like.

A meeting with German photographer Manuela Hofer set me up to visit Berlin another year, as she put me in touch with friends there. Through these contacts I hooked up with a journalist and found myself being followed around by a TV crew who filmed me at work for a German arts programme! On that occasion I had an itinerary of over a dozen sites to visit in different sections of what was formerly East and West Berlin. I visited most locations beforehand to explain my project and show people some images. Through that process we were in a position to travel from place to place quite freely on the night itself.

Jill Waterman

The Photo Essay

The New Year's Eve Project by Jill Waterman
Nikon FM and F3, 24mm, 28mm, 35mm, 50mm and 105mm lenses, Ilford FP4 and HP5 film.

Technique Because I'm usually on the streets or in dimly lit places photographing animated scenes, I generally use a flash to illuminate my subjects. At the beginning of the project I used a flashgun so small it was practically a toy. After I arrived in New York I bought a Vivitar 283 flash and I have used this ever since. I often slow the shutter speeds to mix ambient light with the strobe for motion blur effects, however I also make some extended exposures totally without the flash.

"I visited most locations beforehand to explain my project and show people some images."

→

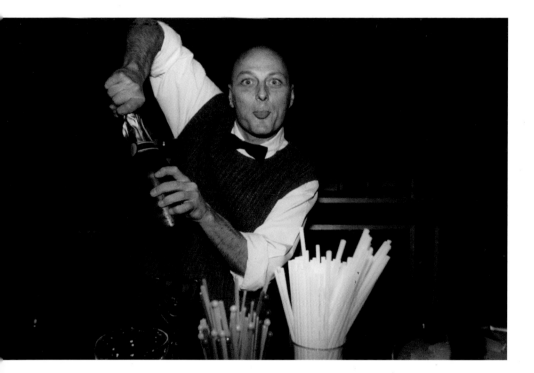

The Photo Essay

The Village School by Bryn Campbell
Leica M2 and M3s, 28mm, 50mm and 90mm lenses, Kodak Tri-X film.

In my experience, both as a picture editor and a photographer, it seemed to me then that reputations were being made almost exclusively by covering wars and dangerous assignments. I felt that there were also other things in life that were equally worthy of coverage even if they weren't so dramatic and exciting.

The year was 1972 and I had the perfect opportunity to put my thoughts into practice, because my wife was the head teacher at a small village school. I knew what her job and the children meant to her and it struck me that this was precisely the kind of quieter story that I had been telling myself was worth celebrating. I received permission to undertake a project based around the school year and for most of that time — with a short break for an assignment at Christmas — I spent two to three days a week in and around the classroom with my camera.

It was a tiny school, just 32 children, two classes and two teachers, and it did take the children a while to get used to me. I had given myself long enough to really get under the skin of the story, however and eventually I became part of the scenery and was hardly noticed. My aim was to be as unobtrusive as possible and, to that end, I shot everything using natural light and worked with Leica rangefinder cameras that were virtually silent in operation.

I wanted to produce a document of a very typical village school at that time throughout a substantial period and I think I achieved that end. There was also a chance for the children and their parents to see the work because around 150 of the pictures were exhibited in 1975 as part of the Chichester 900 Festival. Twenty years later they were also published in book form by Comus Books. At that time I went back to see the village school and discovered that it no longer existed, having been merged, like so many others, into a larger school. It justified my project in many ways, because it has now become a document of something that no longer exists and that gives it a certain importance. It proved to me that some of the best documentary stories could be found simply by looking close to home, which is something photojournalists sometimes forget.

Bryn Campbell

"I felt that there were also other things in life that were equally worthy of coverage even if they weren't so dramatic and exciting."

Pointer I set a very definite time span of one year for the project because I knew if I didn't it would simply go on and on for ever and never had a logical end. Also it meant that the children were photographed throughout a certain period of their lives. If I had stretched the project out over three years, for example, children would have moved on and there wouldn't have been the continuity.

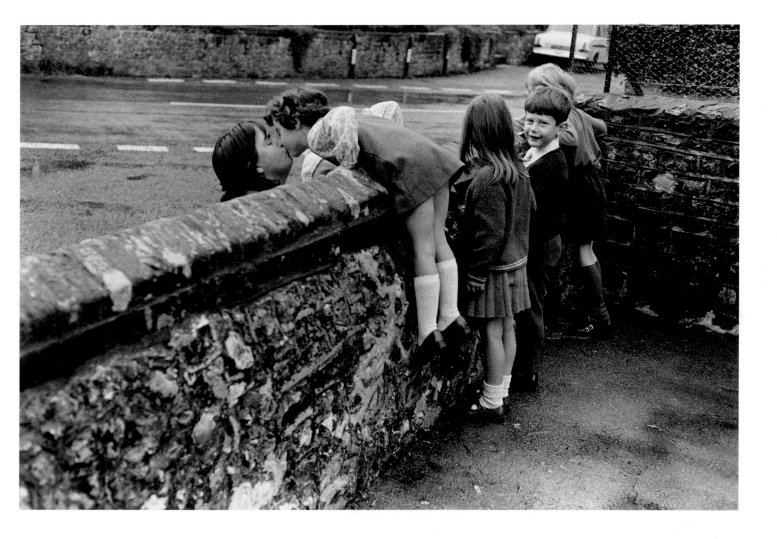

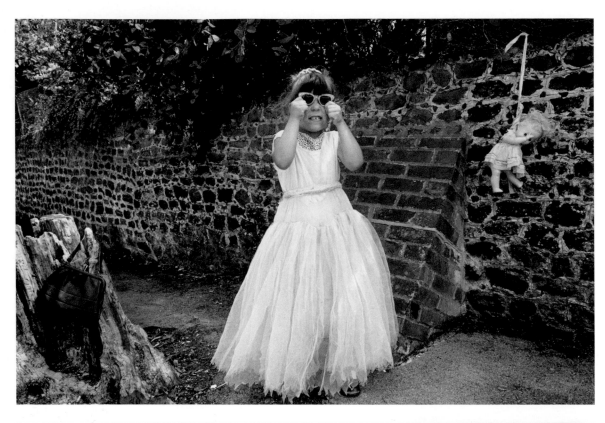

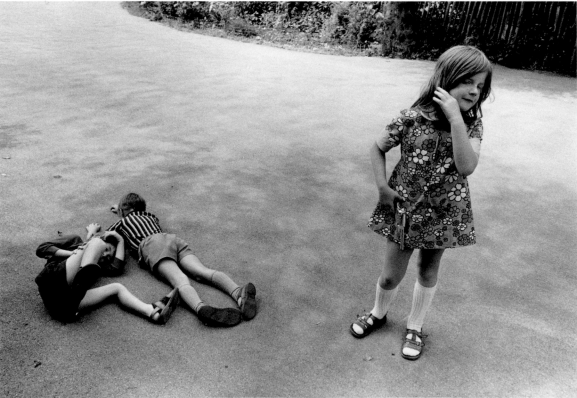

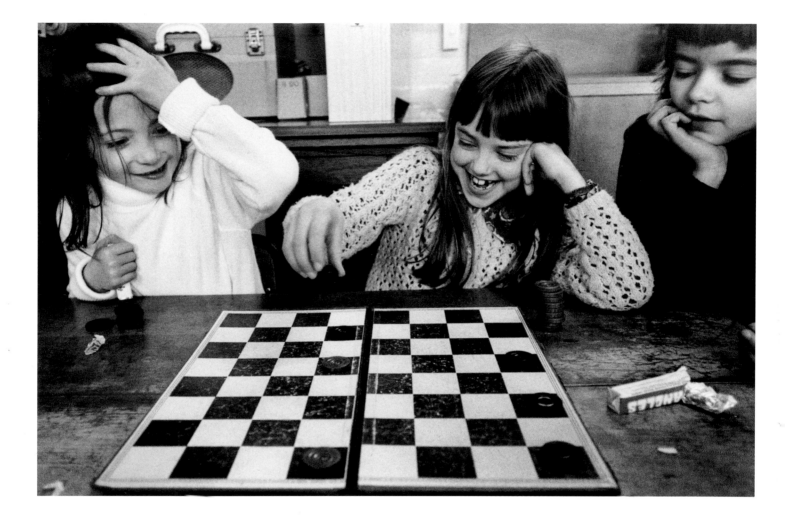

The Photo Essay

London's Disappearing East End by John Claridge
Shot on a selection of cameras including a Pentax S1 35mm SLR with 50mm
and 105mm lenses and a Leica 3F. Film mainly a mix of Tri-X and HP4

I started photographing the east end of London because it was my home and I was mad keen on photography and this happened to be the easiest thing for me to look at. So, as a project, it began in a very straightforward manner and I always pursued it in the way that I felt most comfortable with. I would simply walk around with my camera and just look to find the things that interested me. Nothing was planned, everything was a kind of exploration in a way, but I think, perhaps only subconsciously maybe at the beginning, that I sensed things were changing. It made me make an effort to record some of it on film before it all disappeared, like so many other inner city areas, under the face of extensive redevelopment.

My project began in the mid 1950s and, by the time I began working for McCann Erickson in London a few years later I had built up a considerable number of pictures. These were considered good enough for the agency to give me my first exhibition in 1961 at the tender age of 17! I didn't stop there, however, and although I didn't pursue the project continuously I had several periods where I did add to it throughout the next decade or so. I only stopped in the mid 1970s when, to my mind, a lot of the character had disappeared from the area and my response to it was no longer there.

It was an interesting exercise to undertake and it gave me a good reason to go out with my camera and to use my eyes to see the things that were worth capturing in what was, to me, a very familiar landscape. Things were a little easier then because people were more open and, before the days of the tower block, people lived on the streets more and it was possible to find the characters just by walking around.

Looking back I'm very glad that I did undertake this project because, without it, I would have had little tangible to remember this area by. It was just a question of responding to what was around me and trying to put down my impressions on film. It was no more structured than that, but it seemed to work and to hang together as a cohesive set of pictures.

John Claridge

Pointer Personal projects don't necessarily have to have strictly defined parameters from the outset and many simply develop over the years into something that has a common thread or theme. Photographers looking, as John Claridge was, to hone their photographic skills might find that things that are close to them and that they are familiar with are good starting points and will be something that they can bring individual insight to. The other point to note from a project such as this is how important it is to record the everyday facets of life. Although to some they might not seem important at the time, later on when progress has brought about the inevitable changes, they will allow the work to become almost a document of historical record.

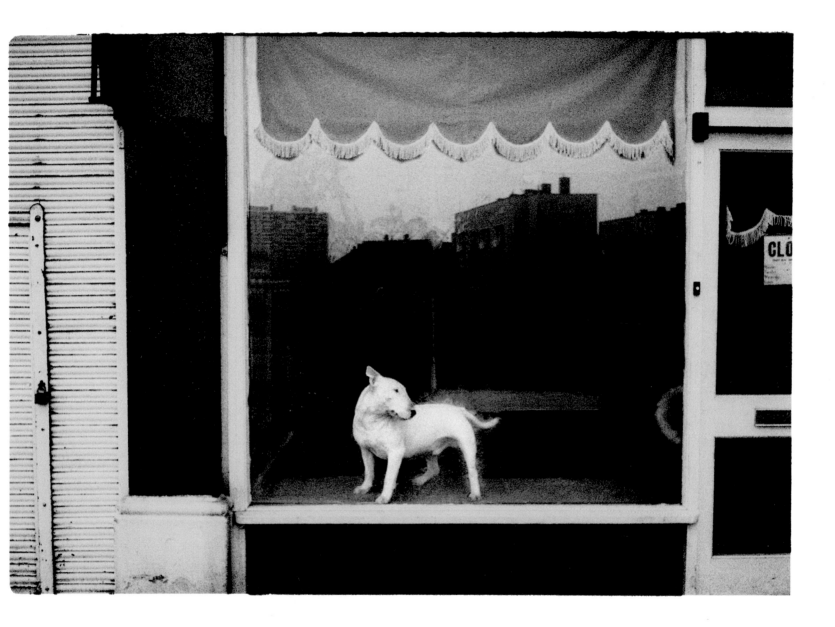

→

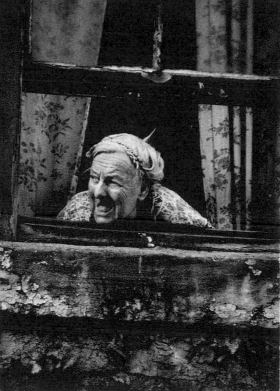

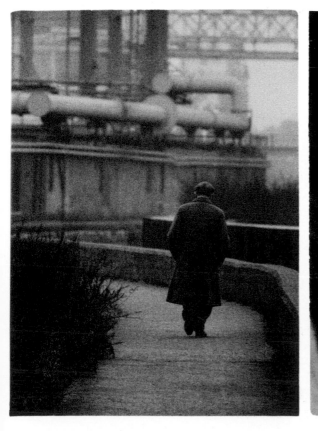

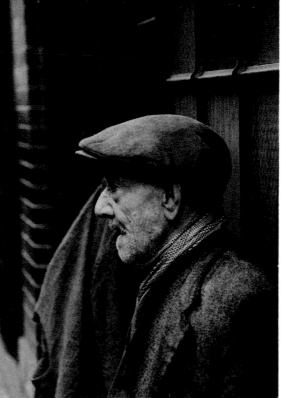

The Photo Essay

Portraiture

Some of the most revealing portraits of them all are produced by photojournalists, the best of whom can extract moments of rare beauty and insight from the most demanding of situations

Portraiture

Destroying a jungle landing strip by Tom Stoddart
Contax RT III SLR, 135mm lens, Kodak Tri-X film.
Exposure 1/500sec at f/11

I was working on a story about Columbian Special Forces and the war that they were waging against the drug cartels in their country. We were travelling on helicopters around the place and it all felt a lot like Vietnam in many ways as went looking for the simple landing strips that had been built in the jungle to allow light planes to come in to pick up drugs.

When we found one we would land the helicopter, dig a ten-foot deep hole in the middle of the strip, plant explosives and then blow them up. This was the second operation of the day and the man in charge of laying the explosives asked if I would take his picture as everything blew. He was very cool: he walked up to the fuse, lit it and then walked away with a cigarette in his mouth. When he was no more than around fifteen metres away from the site there was a massive explosion and I caught the moment just as it reached its height, with the soldier strolling nonchalantly in front. Seconds later rocks and earth came crashing down on me and my camera, emphasising how close we had all been to the point of detonation.

The result is a portrait of a man carrying out a dangerous job – one of his colleagues who I had photographed earlier that day was killed in an ambush that very afternoon – and showing off the bravado that goes with the role.

Tom Stoddart

A pair of 'L shaped' cards used together will help the photographer to see the effect of different crops

Pointer This picture was eventually used on the cover of the **Sunday Times Magazine** and was cropped so that it fitted the required upright shape, losing some of the space down both sides and generally being made a much tighter crop. For me that wasn't a problem, because if a good art director has treated the picture sensitively then I would go along with that – and obviously if I wanted a cover image this picture was never going to fit given its shape. I do generally, however, endeavour to compose my pictures in-camera as much as possible and would trust that those who use my images would appreciate that fact, and would never crop unnecessarily.

The Decisive Moment Experience has taught Tom Stoddart when to press the shutter and here the timing is perfect as the explosion reaches its peak. Even a split second earlier or later would have seriously weakened the impact of the picture. Such expertise is something that only comes with practice, which is why it's important for those hoping to be successful photojournalists to undertake as many projects as possible.

Picture Tom Stoddart/IPG

Portraiture

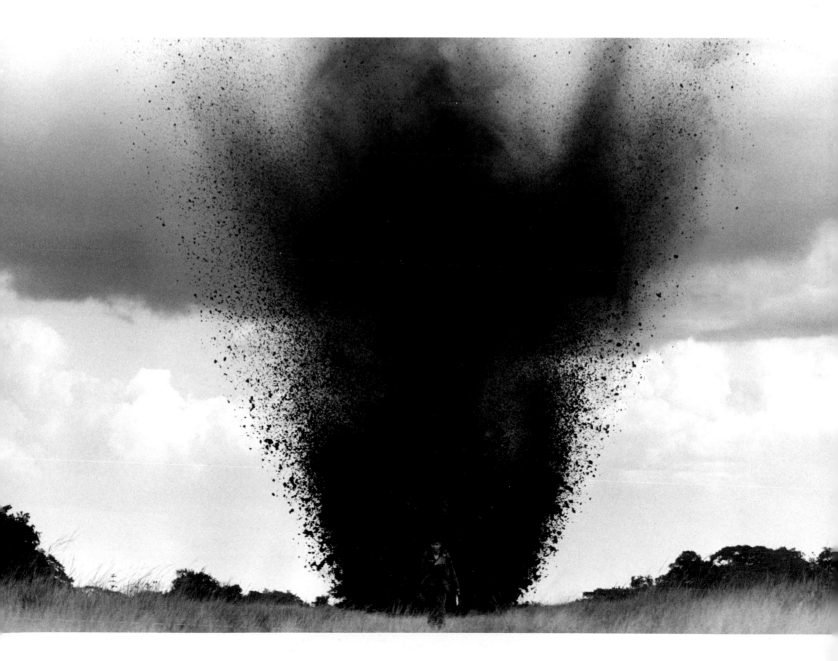

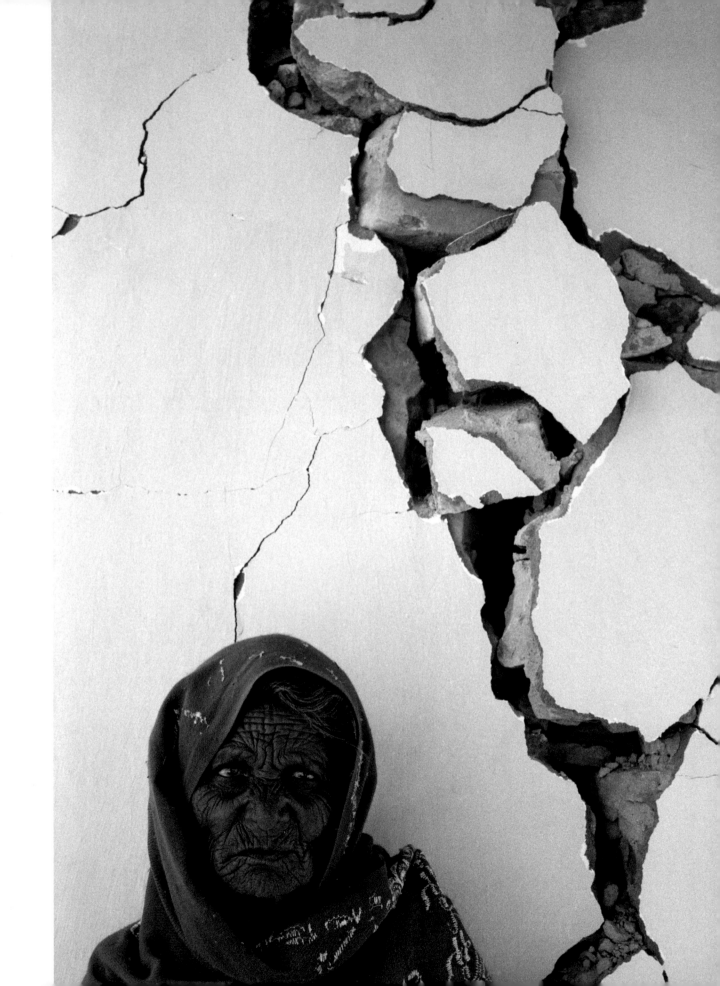

Portraiture

Woman in Indian Earthquake 2001 by Tom Stoddart
Leica M6, 35mm lens, Kodak Tri-X film.
Exposure 1/250sec at f/5.6

The earthquake that struck the Gujarat State in western India in early 2001 was a terrible natural disaster. In 30 seconds some 30,000 people lost their lives, 150,000 were injured and a further one million were made homeless. I arrived just a few days after the event and found myself working in the town of Anjar with the charity Medecins Sans Frontiers, who were trying to offer whatever help they could to those who had survived.

Looking around for pictures I came across this old lady who was sitting quietly in the remains of her house, trying to stay out of the heat of the sun. She was very calm and dignified and had so much wisdom in her face and I realised that this was an opportunity to produce a very powerful portrait.

Even though she had positioned herself in the shade, the light was reflecting from the walls of the building and was picking out the texture in her skin. In short it was perfect and couldn't have been bettered even if I had set the picture up in the studio. I had everything I needed to work with and the final element that completed the picture was the huge crack in the wall right alongside her, which placed the whole image into context. I waited until she looked up at the camera and produced a picture that I think says something about an old lady whose whole world has fallen around her.

Tom Stoddart

Composition Like most photojournalists, Tom Stoddart is very wary of interfering with a scene and this image is exactly as he saw it. Through his choice of viewpoint, however, he has added drama to the picture. The woman herself has been kept quite small within the frame and she's positioned at the very bottom of the picture and to one side. This has allowed Tom to make more of a feature of the terrible damage that can be seen across the wall in the background. By allowing this to dominate the top two thirds of the composition it's emphasised the vulnerable nature of the subject and made a point about the strength of the natural force that created this havoc.

Pointer When a photojournalist is shooting portraits it's important to consider the surroundings and the kind of elements that will say something about a subject's situation. It's not necessary to always state the obvious: Tom Stoddart didn't need to show a wide area of damage to make the point about the serious nature of the earthquake that had struck his subject. A symbol, in the shape of the cracks in the wall, was all that was required and this immediately informed the viewer about the circumstances behind this picture.

Picture Tom Stoddart/IPG

Portraiture

Mujahadeen Trader with Hawk 1983 by John Downing
Nikon F3, 85mm lens, Ilford HP5 film.
Exposure 1/125sec at f/2.8

During the time in the early 1980s when the Afghan rebels were waging a guerilla war against Russian troops, I teamed up with a writer, Ross Benson, and set off to the Pakistan town of Peshawar, which was close to the Afghanistan border. Here we hoped it would be possible to link up with some of the fighters and to make an expedition into Afghanistan itself and possibly even make it into the capital of Kabul, subsequently to produce an on-the-spot story for **The Daily Express** newspaper.

The rebels were keen to get coverage and it didn't take us long to receive an offer of help. Once we started our trek, however, it was hard going, because we were walking for around twelve hours a day, starting early, resting between 12 noon and 3pm when the sun was at its height and then continuing on again into the evening.

I took this picture during one of those midday lay-overs in what was effectively a tea room up in the mountains. Because I was so exhausted I was lying on the floor and this trader came in with a bird on his shoulder, and he had such a striking face that I knew it would make a fantastic portrait.

Strong sunlight was entering the room through gaps in the walls and I just positioned him so that he was in an area of shade so that the contrast levels weren't too high. The sandy coloured nature of the walls helped me a lot, because these bounced light around and helped to soften the shadows on his face.

It wasn't difficult to get him to co-operate with me. In fact he was so pleased to have been photographed that he offered to share an apple that he had. It was a rare treat and one that was very welcome at this particular time!

John Downing

My Favourite Tip When I undertake a foreign assignment I try to find out how long I'm going to be away — obviously in this particular case that wasn't too easy — and then I reckon on using six rolls of film a day and estimate it from there. It's a rough formula but it seems to work, because I've never run out of film to date. I usually end up shooting more like ten rolls for the first two days and then become more discerning and shoot far less. It's the same way that I would react if I saw a bomb going off. I would shoot pictures of everything as fast as I could, practically sweeping the scene with my camera, then become more selective, getting more detailed and considered images.

Pointer We were hoping to make it into Kabul with the rebels but it was too dangerous and we couldn't get them to take us in, although we did make it to a town called Ganzi where there was also a lot of fighting. We had promised ourselves that if we made it to Kabul we would call on the British ambassador there and have tea with him. Ultimately, a year or so later, we managed to persuade the Russian side to let us accompany their troops to Kabul to photograph the war from their side and this time we did get to the embassy — but for dinner!

"Strong sunlight was entering the room through gaps in the walls and I just positioned him so that he was in an area of shade so that the contrast levels weren't too high."

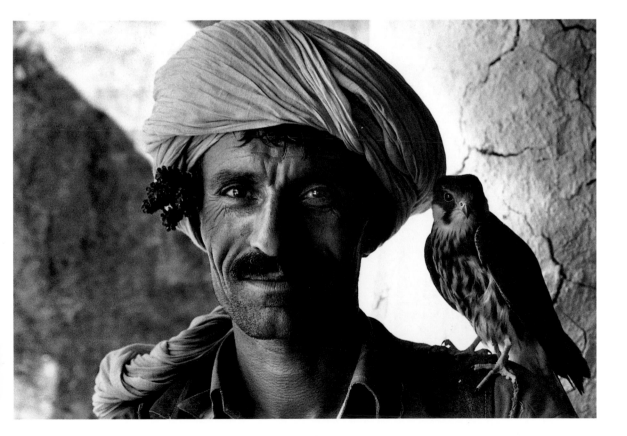

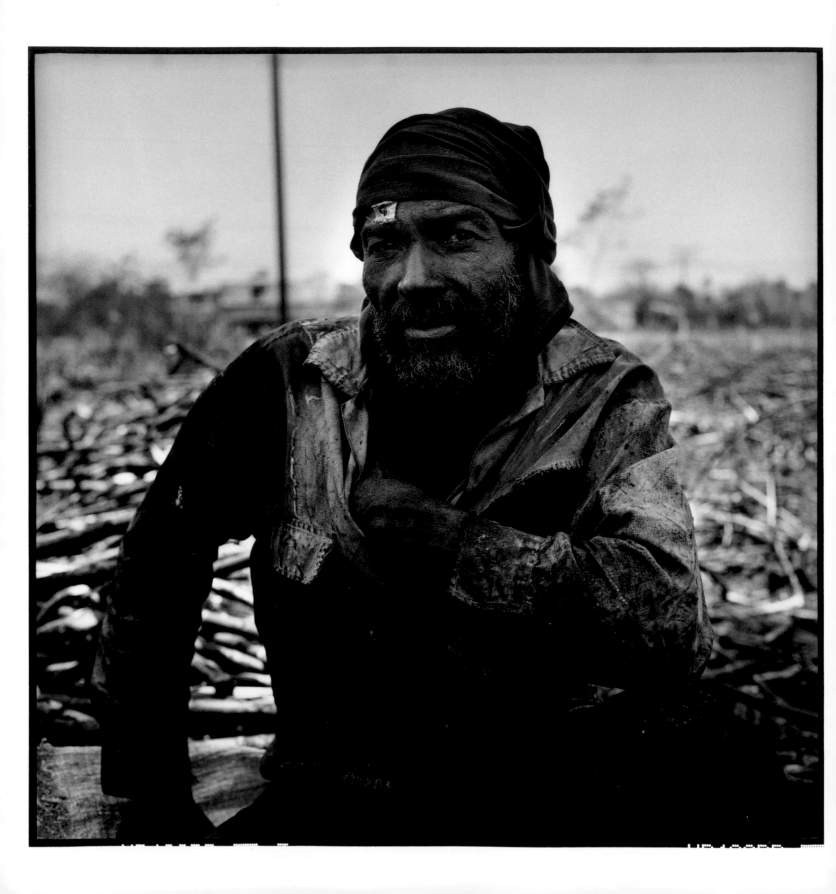

Portraiture

Sugar Cutter in Cuba by Adam Hinton
Mamiya 6, 75mm lens, Fujifilm Neopan 400 film.
Exposure 1/500sec at f/4

I had been working very hard and had a few days spare and decided that I would travel and take pictures to relax. There was a wide choice of countries that I could have gone for, but I decided on Cuba, because I'd visited once before and the timing, May Day 1999, the country's 40th anniversary, seemed quite fortuitous.

With just over a week to play with, I decided on the flight over that part of my itinerary would concentrate on different parts of Cuban industry. Although it wasn't really the right time of year, I was particularly keen to photograph sugar cutters if I could find any, because they are such a symbol of the island. I duly hired a tourist guide and a taxi for the day and, much to their surprise asked them to take me out of Havana to visit some sugar plantations. At the first one I struck lucky and I was able, with the help of the translator that I had with me, to persuade one of the sugar cutters that I met there to pose for a few pictures for me.

It's hot and horrible work to do and involves burning all the cane so, out in the fields, there's not even any shade during the heat of the day. This man had been cutting sugar for 40 years, which is longer than I have been on the planet, and he sat down and just looked at me in a very calm and unpretentious way. Set in the context of where he's working and wearing the clothes that have been made filthy by the nature of his job, I believe that the picture says a lot about him and the kind of job he does. It's a dignified portrait of manual labour.

Adam Hinton

Technique The direct light in the middle of the day was intense and would have created very unflattering areas of contrast around the sugar cutter's face and body, so I sat him down in the shade of a tree and photographed him there, positioning him carefully so that the light in that part of shadow was nice and soft. The background, which was being hit by sunlight, was quite dense on the negative and so my printer, Gary Wilson, gave extra exposure to that area in the darkroom to even things out.

Printing and Processing Adam Hinton's printer Gary Wilson was faced with an image that featured a wide range of contrast and he realised that he would have to balance this out to achieve a pleasing result.

"Printed straight the background was very bright and the lower half of the man's body was very dark," he says. "To get around this I made a basic exposure of 18 seconds on Multigrade paper at grade $3^1/_2$, holding back the lower half of the body by around three to four seconds to keep more detail there. I also wanted to lighten his eyes a touch and so I use a piece of wire with a blob of BlueTac on the end to just take a second or two out of this area without making it appear too contrived.

"Once this initial exposure was finished I changed the filtration so that the paper was now a grade 2, because this meant that I could burn in detail around him, bringing up the highlight detail without darkening down the shadows to the point where the effect would have been noticeable. I gave an extra seven seconds to his left hand side, ten seconds to his right where the density of the negative was slightly greater and a couple of seconds more to the gap between his arm and his body, where the negative was denser still. I didn't give anything extra to the sky at all because the brightness there helped to accentuate the figure and I was also concerned to avoid giving more emphasis to the pole in the background."

Pointer Many photojournalists automatically reach for a 35mm camera, but you shouldn't overlook the benefit of a medium format model. For a portrait such as this, which is not a snatched image, the time is there to set up the picture and the extra quality which the bigger negative size will offer can be hugely beneficial. With a 6x6cm model there is also the chance to work with a square format, which can be ideally suited to the dimensions of a portrait such as this.

Portraiture

Boy Studying After School, Northern Ghana by Marj Clayton
Nikon FM2, 105mm lens, Ilford Delta 100.
Exposure not recorded

I was visiting a friend's community in Northern Ghana and was brought to meet the elders and chiefs and all the relatives in the village. This little six-year-old boy was hanging around and I got to know him also and found out that he was an orphan. I grew very attached to him during our stay because he was always helping us and I decided to persuade the local school to give him a place.

This portrait was taken during his first week of school and he was doing some extra studying after coming home. He would come in, find the food set aside for him, clean the dishes and then get his books out. He was a very spontaneous guy and he just kept doing things that I wanted to photograph. Initially I set up a tripod and stood alongside it so that I could talk to him and try to photograph him while he was concentrating on me but eventually he was moving around too much. I've got a quick release plate on my tripod and so I took the camera off and then took most of the rest of my pictures hand holding with the lens wide open, shooting generally at around 1/15sec during the odd moments when he was still.

Marj Clayton

Technique I hate using flash because I think it kills the atmosphere and so I look for natural light and try to work around it. Here the building we were in had very high walls but there was a gap around the top of them that was not glazed in and so light was coming in through there. I also find with doors and shuttered windows it's possible to adjust things so that you can, to a certain extent, control the quantity and direction of light that you're getting. I'll also use reflectors to bounce natural light around and to direct it into the places that I want it.

Pointer I use my camera's meter to give me a guide to exposure but sometimes it's almost too exact and is failing to take account of all the prevailing conditions. At those times I'll prefer to rely on the light meter in my head to give me a more accurate reading. The exposure I give needs to reflect such things as the skin colour of my subject and I might choose to open up a stop to retain detail in relatively low light level situations such as this. I find a good way to judge an average exposure is to take a reading from the inside of my outstretched palm and then I can make an adjustment from there if necessary.

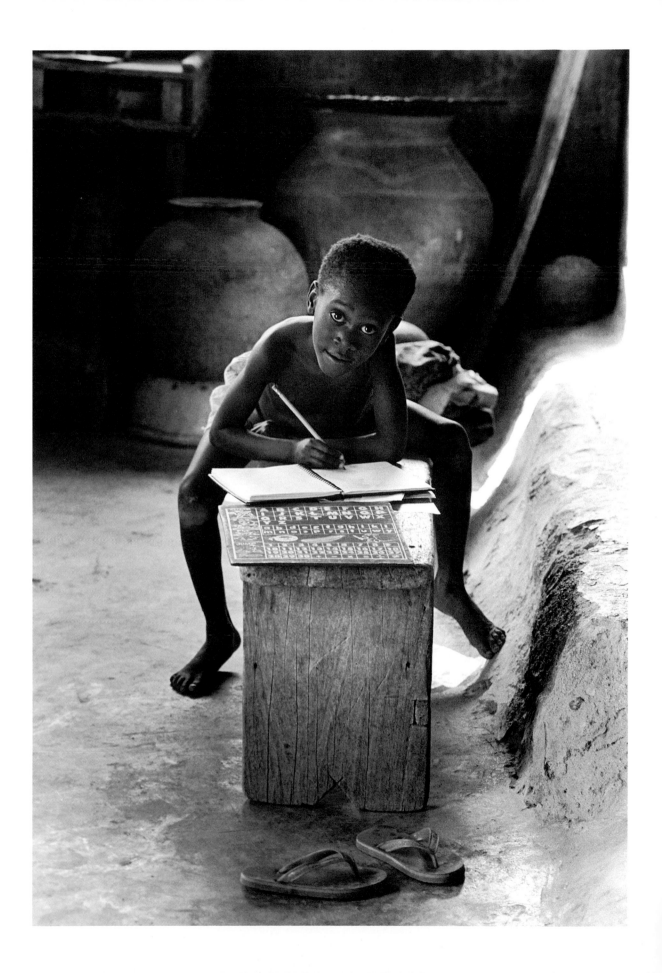

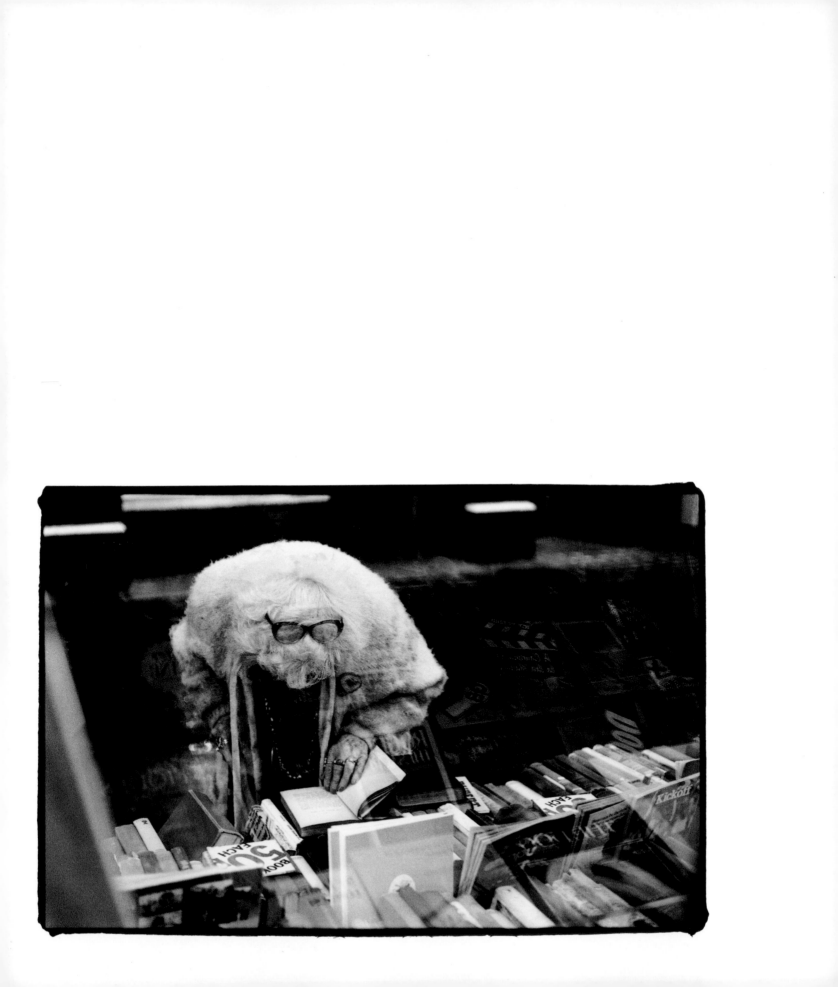

Portraiture

Woman browsing in bookshop by David Gibson
Nikon FM2, 50mm lens, Kodak T-Max 400 film.
Exposure 1/30sec at f/1.8

I was passing a bookshop in London's Charing Cross Road area when I suddenly saw this woman totally absorbed as she searched through the books piled up on a table outside. Immediately I knew there was potential for a memorable photograph, but to get it I had to get in front of her because from behind it simply did not work. I was fortunate that her interest was in the books: she was totally oblivious to me and I was able to edge quite close, tightening up the composition as I went. The moment was there: I just had to be bold.

It could be argued that I could have got closer still, because there's still an edge of shelving that has recorded as an out of focus strip on the left hand side of the picture. However, this picture is more about content than composition.

David Gibson

"This picture is more about content than composition."

My Favourite Tip I'm always looking for pictures and carry my camera with me everywhere. There are all kinds of situations that you could miss if you left the camera at home: I would have been devastated not to have taken this photograph because it was such a gift. I suppose it is about looking for the luck.

The Decisive Moment The first pictures that David Gibson took of this scene were not particularly successful, but he had time to react to the situation and worked his way around until his viewpoint was more revealing. Then he slowly pared the picture down to its essential elements, removing all the unnecessary detail. The final picture of the sequence required all aspects of the picture to tell the story: the woman's hand holding open the page of the book as she scours through it is the final telling touch that completes the image.

Portraiture

A Drive in Hyde Park, London 1953 by Thurston Hopkins
Leica 35mm rangefinder camera, 35mm lens, Ilford HP3 ISO 200 film.
Exposure not recorded

I was heading into Fleet Street in London one day and had been promised a lift by someone who was going to pick me up at Hyde Park Corner. As I stood on the kerbside waiting, the lights turned red and this Rolls Royce slid across my view. I got this vision of a chauffeur in full uniform sitting at the wheel next to a huge and very regal looking dog. I was so amazed that for a moment I couldn't react and then the lights changed and the car pulled away. I knew it was an opportunity not to be missed and so I hailed a taxi and gave chase, catching up with the Rolls Royce some way further on.

It turned out that the chauffeur was the owner of a car hire firm in nearby Mayfair who, for a bit of a joke when business was slack, put his dog in the car and took him for a ride. I was still stuck in terms of taking a picture because I had been working late in London the night before and had left all my camera gear at the **Picture Post** offices and had been intending to pick it up later that day. Fortunately the man agreed to meet me the following morning and I was able to restage the picture exactly as I had seen it.

It's since gone on to become probably my most famous picture and is so well known that it's become something of an albatross around my neck! Everyone thinks it was taken for **Picture Post** but in fact, although I was a staff photographer there and had been commissioned to produce a series on dogs of London for the magazine, myself and the editor were given the boot as part of a management reshuffle before the story was used. Working then as a freelancer I eventually sold it to the rival title, **Illustrated**.

Exactly a year later the editor at **Picture Post** got his job back, called me up and I found myself back working for the magazine. It was like going home.

Thurston Hopkins

My Favourite Tip The 35mm lens is a wonderful lens for the photo journalist to use and the quality of the f2.8 Rodenstock Heligon optic that I was using was so good that it virtually became my standard lens throughout my whole time at Picture Post.

Pointer Some photo journalists refuse to allow work to be cropped but, on occasions, the format of the 35mm negative simply isn't the right shape to suit the picture that the photographer wants. Here Thurston Hopkins has strengthened the picture considerably by cropping so that the window of the car has been framed precisely. Anything either side was extraneous and would have diluted the strength of the image.

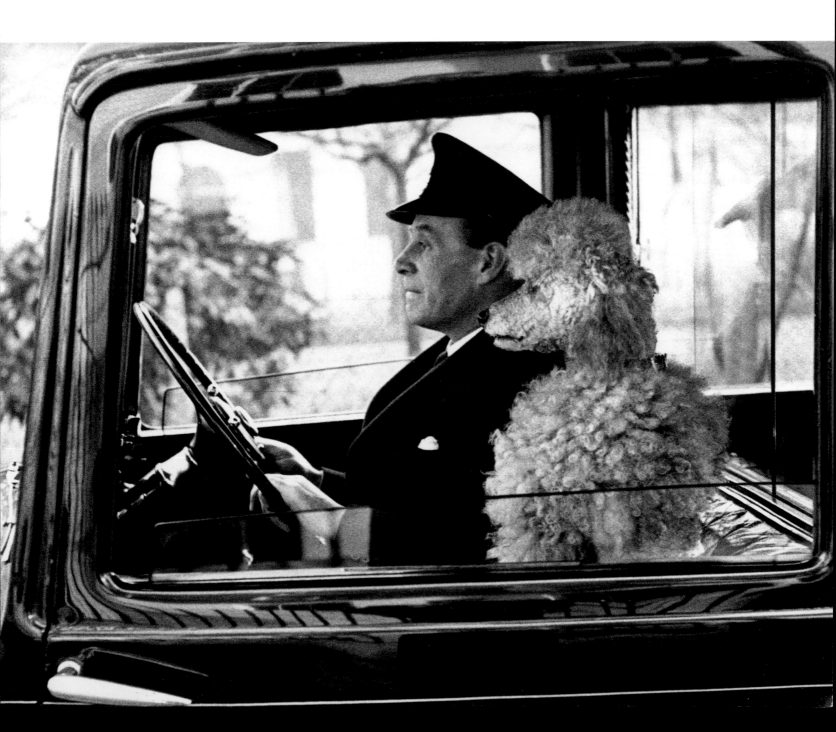

Portraiture

Conservative Party Conference 1996 by David Modell
Canon EOS 1, 28mm lens, Kodak Tri-X film.
Exposure 1/125sec at f/2.8.

I worked on a project to cover the British Conservative Party for around six years. When I first started it in 1995 they were in power but appeared, to me at least, to be so detached and irrelevant to everyday society that I felt compelled to try to document what was going on and to take a look at their identity at this particular time.

This was taken at the last Conservative Party conference before the election that swept Tony Blair to power and, to be honest, it was a gift. These twins were sitting in the front row of the seats and it seemed to me at the time to be too easy for it ever to be seen as a decent picture. It has, however, gone on to become one of the most memorable pictures from the entire project.

I simply took up position and waited for a time when they were animated. This wasn't difficult because there is a lot of clapping and obligatory standing ovations at one of these conferences and so it was just a question of waiting.

When I started the project it was difficult to get access but after the party went into opposition things became much easier because there was less interest in what they were doing. Over the years I built up a relationship with the party's then-leader William Hague and others around him. I wasn't particularly sympathetic to their cause but, to get a good level of access, you play a calculated game over a long period of time and have to convince those that you are photographing that they are getting something out of it.

David Modell

Composition To make this picture as strong as possible I took up a position directly in front of the twins and this allowed me to set up a completely symmetrical composition. It almost looks like a mirror image, even down to the clapping hands.

Technique I took this picture with available light and rarely, if ever, use flash for any of my work. I just feel that it destroys the atmosphere and, in any case, it's rarely necessary when you're using black and white film. I can uprate to ISO 800 should it be necessary and, when I'm using my Leica M6 rangefinder camera, it's so well balanced and has such a high quality lens that I can shoot hand held at 1/8sec at f/2 with no problems. The only time I might have to resort to flash is when I'm covering something that is very dark and movement is involved: I did a project that involved documenting people at Christmas parties once and that was impossible to cover in any other way.

Picture David Modell/IPG

Perfect symetry within the picture, created by the composition, has emphasised the theme of repetition here

"To get a good level of access, you play a calculated game over a long period of time and have to convince those that you are photographing that they are getting something out of it."

Portraiture

Boy Recovering from Leukaemia 1969 by Bryn Campbell
Nikon F, 24mm lens, Kodak Tri-X film uprated one stop to ISO 800.
Exposure 1/250sec at f/2.8

This is a single image from a lengthy assignment I carried out for **The Observer Magazine** about a small boy who was suffering from leukaemia. It was a very moving and touching story that required me to try to stay as much in the background as possible, which was not easy given that I was one of the very few people allowed into the room where the boy was being treated.

I had to be gowned and given a mask in the same way that the nurse was in order to make sure that I didn't pass on any infection to the boy, who was very vulnerable at this time due to the treatment he was receiving. Even his family couldn't enter the room and could make contact with him only through an intercom.

The first pictures I took were quite distressing, because the boy was very listless and depressed and he was missing his family terribly. Over the next few weeks he responded to treatment and the pictures I took showed him becoming more lively and building up a bond with his regular nurse.

This particular image was in sharp contrast to those taken at the start of the project. The boy was now well enough to be kicking a ball and was starting to regain all his old energy. It was, obviously, a telling portrait that brought this stage of the story to a happy conclusion. To take it in the confined space of his treatment room I needed to fit a 24mm lens, which is wider than I would normally be happy with, and then work around the situation as it developed. I positioned myself so that I was roughly the same distance from both my subjects, so that I could work at maximum aperture without having to worry about depth of field, and I waited for the moment when the boy's pose said everything about the recovery of his spirit.

Bryn Campbell

My Favourite Tip I used available light in this situation, which is what I try to do whenever possible. It helps you to work quicker and to announce yourself far less and it saves unsightly harsh shadows being created that take away all the atmosphere from the scene that you're photographing. By uprating my Tri-X film one stop to ISO 800 I was able to get just enough speed to allow me to hand hold for all my pictures for this story.

The Decisive Moment Not wishing to influence his subjects unduly, Bryn Campbell waited for a telling moment to shoot as this impromptu game of football developed. By pressing his shutter at the moment the boy's leg was raised in the air he has achieved great spontaneity in the picture and has visually emphasised the point that the boy is starting to regain his natural energy.

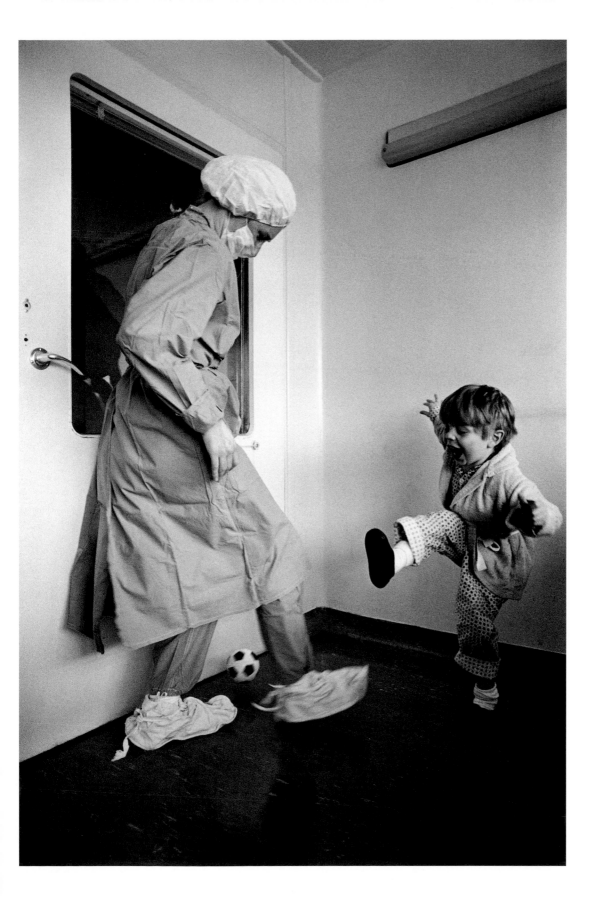

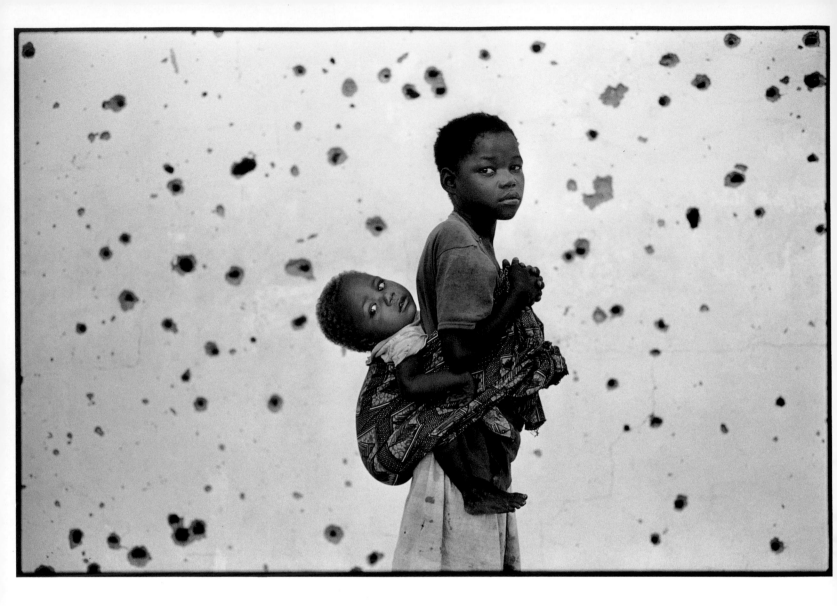

Quito was a town in Angola that had been at the centre of the fiercest of the fighting that took place in that country between rebels and South African backed government forces. As a result the whole place had been totally destroyed: there was almost nothing left standing and the few walls that remained looked like this, covered in pockmarks where shrapnel and bullets had left their mark.

I was in Quito to cover the aftermath of the war and was looking for images that would sum up how the people there were coping now that peace had returned. These two sisters were coming down the street and I realised that they would make a wonderful portrait, particularly if they were seen against a wall that bore the scars of the recent conflict. I asked them if they would mind if I took their photograph and they just stopped and looked at me and that was it. I also took a few versions where they were looking away from the camera, but it's the intensity and the sadness in the eyes that make this portrait so special, and so this was the most successful image.

Dario Mitidieri

Quito, Angola by Dario Mitidieri
Leica M6, 35mm lens, Kodak Tri-X film.
Exposure 1/125sec at f/4

Composition I decided to place the two girls directly in the centre of the picture, because to my way of thinking this was without a doubt where they had the maximum impact. The rules of photography might choose to differ: there is a train of thought that says it's best to place subjects to the left of the picture so that they have space to look into, but I don't feel that would have been so strong. Rules are made to be broken and this image proves the point.

Pointer Because the picture looked so strong when I first came across it, there was a temptation to shoot quickly and to assume that everything would work out. I held myself back, however, and took great care to place the girls so that the pockmarks behind effectively framed them. This made the picture very clean: had they covered some of the marks it would have looked very messy and the picture would have lost much of its impact.

"I was in Quito to cover the aftermath of the war and was looking for images that would sum up how the people there were coping now that peace had returned."

Portraiture

Natalie's self mutilated arm by Felicia Webb
Leica M6, 50mm lens, Ilford HP5.
Exposure 1/60sec at f/4

I am working on a long-term project about people suffering with eating disorders, and I came across Natalie, who has endured a lifetime of anorexia, because someone else that I was photographing suggested that I have a look at her website. I emailed her and then met up and showed her my work, and she was happy to be part of the project.

The way that I work is based purely on trust and, with something as personal as anorexia that's the only way that I could get close to people in any case. I had taken so many pictures of Natalie that she had totally accepted my presence and this was how this portrait came about. She was in bed with her partner Heather one morning and I noticed that the two of them had their arms entwined. Natalie's arm bore the scars of her self-mutilation: this is something that anorexics often do because it expresses their anguish about themselves and their lives.

Immediately I could see that this was a strong image and I asked Natalie and Heather to stay as they were and took my pictures. I just work with what I'm presented with and I didn't change anything. The light was just the natural light that was coming into the room through a window and the spotted background was the duvet that covered the bed.

Natalie half apologized for the unwashed duvet, but I was pleased because I felt that the spots would somehow set the scars off, making them clearer.

Felicia Webb

Pointer I couldn't conceive shooting this project in colour. I feel that the use of alluring colour in this story would be irrelevant and disturbing. I wanted to refine the project down to its dramatic elements and I felt that I could do this more simply and clearly in black and white.

The Photo Essay I started my project on anorexia by approaching the Eating Disorders Association and, after persuading them of the integrity of what I was I doing, they allowed me to place an appeal in their journal for women who would be willing to be photographed. So many people responded that I was immediately able to move it all on and to start taking pictures and it's grown from there. I'm completely committed to it and will follow it through and add to it for a number of years. Eventually I intend that it will become an exhibition, a CD ROM and hopefully also a book, all of which will help to highlight what is one of the most important, and under publicised, social issues of our time. It's proved to me that there are important photo essays that can be carried out close to home and that it's not necessary to travel to the ends of the world to find an extraordinarily moving and worthwhile subject.

Picture Felicia Webb/Katz Pictures

Gallery

It's time for a treat. Sit back and enjoy this collection of wonderful pictures, from a selection of great photojournalists

South China Child Gymnast by Tom Stoddart
Leica M6, 35mm lens, Kodak Tri-X film.
Exposure 1/250sec at f/2

Picture Tom Stoddart/IPG

Boy and toppled Lenin statue by Dario Mitidieri
Nikon F4, 80-200mm zoom, Kodak Tri-X film.
Exposure 1/250sec at f/5.6

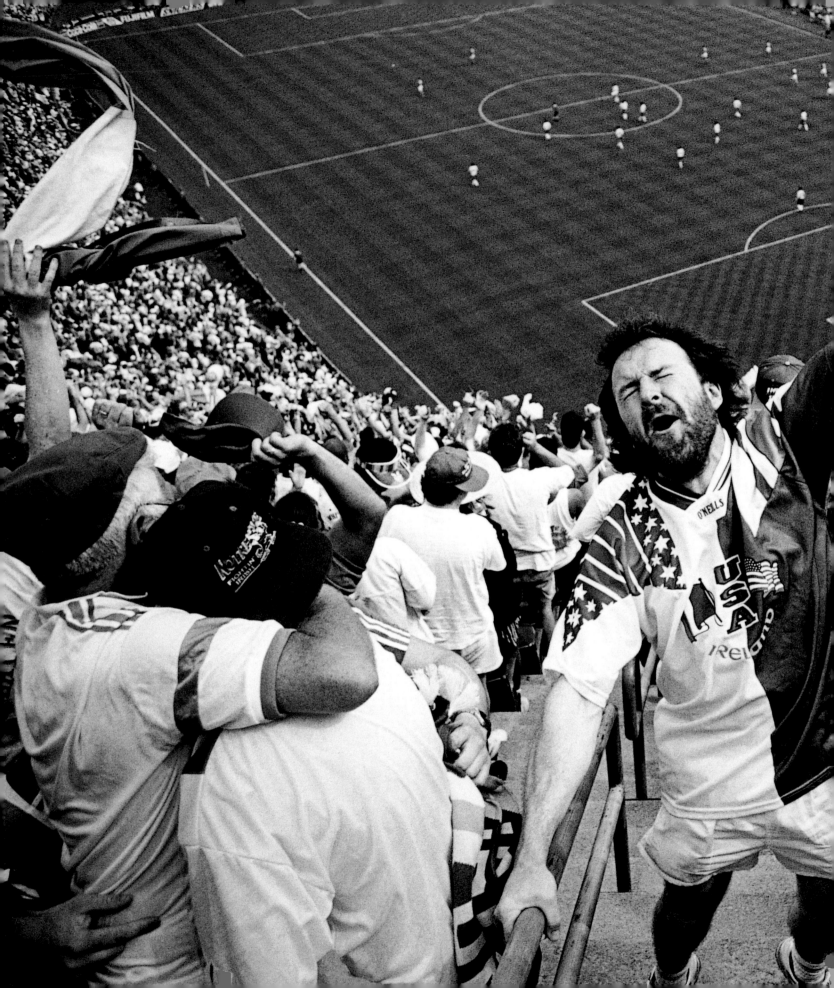

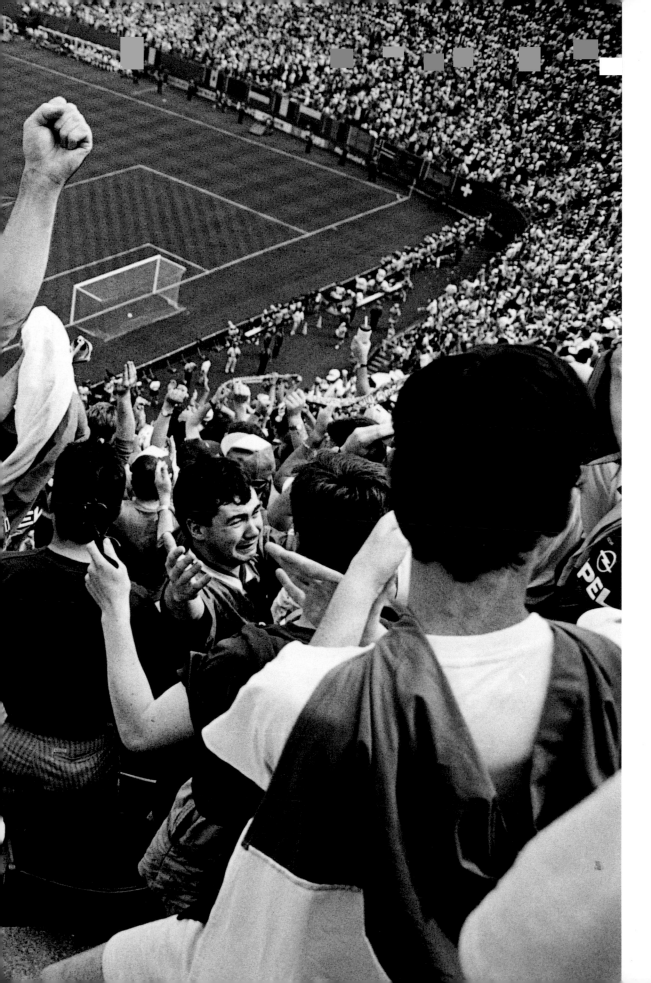

**Irish Fans Celebrate a Goal at the 1994
World Cup by David Modell/IPG**
Canon EOS 1, 28mm lens, Kodak Tri-X film.
Exposure 1/500sec at f/8

Man and Sign by David Gibson
Nikon FM2, 50mm lens, Ilford XP2 film.
Exposure 1/125sec at f/8

Girl with Broom, Northern Ghana by Marj Clayton
Nikon FM2, 105mm lens, Ilford Delta 100.
Exposure not recorded

Anorexia project: Natalie's daily supply of drugs by Felicia Webb
Canon EOS 1, 50mm macro lens, Ilford HP5 film. Exposure 1/30sec at f/5.6

Picture Felicia Webb/Katz Pictures

Tone, Texture

and Contrast

The photojournalist learns to appreciate and to use the light that's given, to reveal something special about the scene that's being pictured

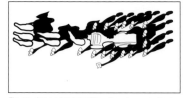
The sun when overhead at midday will create very short and intense shadows

The funeral of Diana was one of the biggest news events to hit London in recent years and I looked around a few days before the event to find a suitable vantage spot from which to photograph it. Eventually I came across a position on a balcony at Knightsbridge Barracks that looked perfect: the picture I had in my mind was one that would show the cortege in the context of the background of the city as it came towards me.

A lot of persuasion and the involvement of **The Daily Telegraph** newspaper were required behind the scenes before I could get permission to take up this vantage point but eventually someone appropriately senior at the Ministry of Defence gave their approval.

On the day, however, everything changed because the light was so intense and directional. As the procession approached I suddenly realised the potential of the situation and knew that there would be a very dramatic picture created by its shadow as it passed almost directly underneath my position. It was a reaction that was completely instinctive and it all happened so quickly. There was probably just a matter of one second where everything was in exactly the right position for this picture to work.

David Modell

Composition The picture needed to be composed in a completely symmetrical way to achieve maximum impact. Everything here is in exactly the right position and this is the only frame where that happened. Looking at the contact print the images either side of this one are nothing like as successful.

Technique The contrast levels were very high in this scene but I knew that what I needed to do was to expose for the mid tones. The grey of the road surface was ideal and so I took a spot meter reading from this area and then allowed the shadows to darken down to add to the drama.

Picture David Modell/IPG

Tone, Texture and Contrast

The Funeral of Diana, Princess of Wales by David Modell
Canon EOS 1, 100mm lens, Kodak Tri-X film.
Exposure 1/1000sec at f/5.6

"There was probably just a matter of one second where everything was in exactly the right position for this picture to work."

I was shooting a project on the religious sect known as the Jesus Army and I took this picture at a service that they were having where a spotlight that was being projected through a screen to create a pattern was being swung around a darkened auditorium. Every now and then it would be stationary for just a few moments and then it would move on. I knew that, if I could get my timing right, that there was the potential for a picture that would not only be dramatic but which would say something about the Jesus Army itself.

The whole culture of being a photojournalist revolves around seeking out the decisive moment. It's all to do with what you want to say about your subject and then looking for things that will represent the way that you feel about them.

In this case I had noticed the looks on the faces of the people as the light fell on them and I knew that the combination of striking shadow and devoted expressions would serve to make a powerful pictorial point for me.

David Modell

Pointer Exposure was very difficult to work out in a situation like this but I knew that I wanted to expose for the area of the picture that was being hit by the light and that the intensity of this was likely to be quite consistent wherever it fell in the room. My Leica features a centre-weighted light meter and so I followed the light around with my camera and waited until I could fill the centre of the frame with it and took a reading at that point. After that I simply stayed with the same exposure for the rest of the time that I was shooting in these conditions.

Technique It's relatively straightforward to rate black and white films at higher ISO speeds to enable low light situations to be covered. What you're doing in effect is giving the film less exposure than it requires, and so to compensate you need to increase development time. This will inevitably cause the grain size to increase, but usually this is within acceptable limits. Pushing two to three stops is quite possible without quality suffering greatly, and with an ISO 400 film such as Tri-X this can mean that you're shooting at ISO 3200, perfectly sufficient for extreme low light photography. Film manufacturers such as Ilford and Kodak should be able to advise you regarding increased development times for specific black and white films.

Picture David Modell/IPG

Tone, Texture and Contrast

The Jesus Army by David Modell
Leica M6, 35mm lens, Kodak Tri-X uprated two stops to ISO 1600.
Exposure 1/125sec at f/2.8

Tone, Texture and Contrast

Bombay 1992 by Dario Mitidieri
Leica M6, 35mm lens, Kodak Tri-X film, pushed one stop to ISO 800.
Exposure 1/30sec at f/2

These children were two sisters, Sabina (9) and Nafisa (4) who I photographed in a police jail just after they had been picked up as part of a round-up of runaway children in Bombay. They had been found at the local railway station and were eventually due to be sent to one of the big remand homes in the area, from where they would either be reunited with their family or sent to juvenile court and then on to a home for girls. Whatever happened, it was bound to be a long judicial process and the faces of the children sum up the resignation that they felt at this time.

I hate using flash because I feel that it ruins the natural atmosphere in a picture, and it also makes the subject more aware that you're photographing them, which can also have a detrimental effect. This being the case I decided to shoot with just the very limited light that was in the jail, the majority of which was coming from a small window just up on the right above the girls. This has picked out their faces while allowing shadows to close in around the edges of the picture, helping to isolate them and to increase their sense of vulnerability.

Dario Mitidieri

Pointer This kind of picture will usually only result when a photographer has a chance to really get immersed in a story and yet the theme of Bombay street children, which Dario Mitidieri was following, was uncommercial in many ways. However the chance of significant funding arrived via an important award and the project snowballed from there to become one of the most celebrated books of photojournalism, 'Children of Bombay,' to be published in the 1990s.
"I was in India initially working on a story for **Der Spiegel** magazine on street children," says Dario, "and I put together a selection of these and the in-depth outline of a much more involved project and submitted this for consideration by the W Eugene Smith Memorial Grant in Humanistic Photography in 1991. This is one of the top photojournalist awards in the world and I was lucky enough to win, receiving $20,000 to enable me to spend the whole of 1992 in Bombay shooting the pictures that I had planned.

"Subsequently I submitted the completed body of work to the European Publishers Awards and won that too, the prize being the publication of the pictures in a book that was published simultaneously in six countries across Europe. Finally the project was awarded the Visa D'Or at the International Festival of Photojournalism in Perpignan, the most important festival of its kind in the world."

Technique Black and white film is hugely adaptable to most situations. Because the light was so poor, Dario Mitidieri decided to uprate his Tri-X material one stop from ISO 400 to ISO 800, simply by changing his camera's film speed setting. Because the film had then effectively been underexposed it required extra development (film manufacturers will give precise timings for different developers on request). The result was a touch of extra grain, but in a situation such as this was a small price to pay for a film that immediately was rendered more sensitive and more capable of coping with low light.

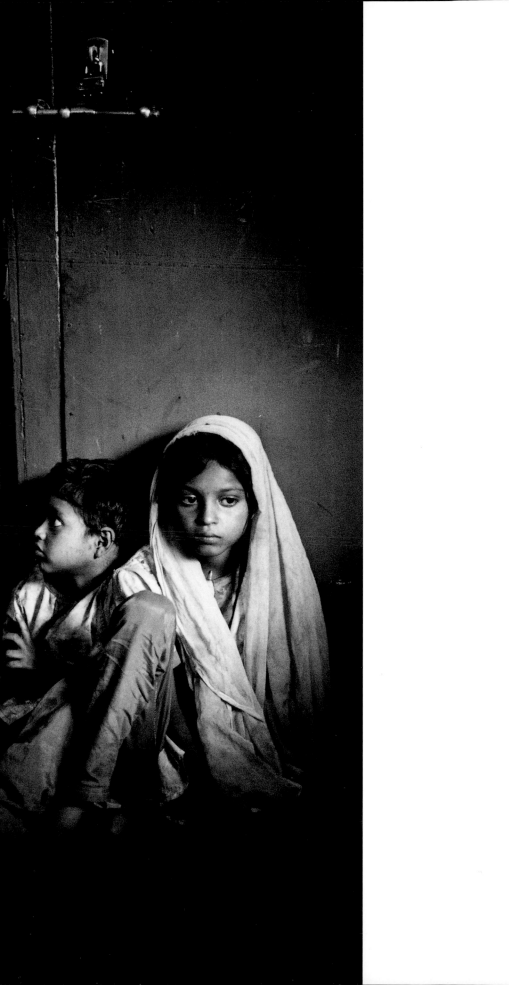

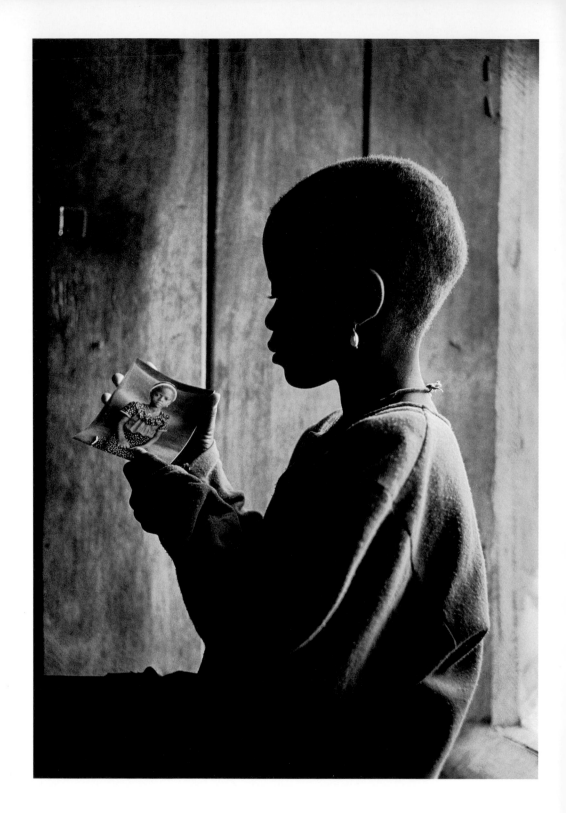

Girl looking at her photograph by Marj Clayton
Nikon FM2, 105mm lens, Ilford Delta 100.
Exposure not recorded

I was visiting a friend of mine who had relatives in many of the villages and townships around Northern Ghana and while I was travelling around meeting some of them I took photographs, always returning later to hand out prints. This little girl was someone whose picture I had taken earlier in my stay and I took this portrait just after I had handed her this photograph of herself. It was a lovely moment and you could tell that she wasn't used to being given anything this delicate because of the awkward way that she's holding it.

Automatically I will always look for the tone and texture in a scene and I loved the way that she was sitting in an area of shade while the open door behind was catching the light and providing a backdrop to her. It was almost a silhouette but there was the chance to retain some detail of the back of her head while the light falling on the print in her hands allowed me to pick this out so that it was clear what she was looking at. It's almost a perfect profile and she was so intent on looking at her new possession that she held this pose for some time while I figured out the best exposure to set.

I decided that the print and the door were the crucial elements of the picture to expose correctly, while it didn't matter so much if the shadows on the girl's face darkened down a little. By taking a reading from the door and another from the palm of my hand I was able to come up with a balance that suited this scene and allowed me to capture the atmosphere that I wanted.

Marj Clayton

Printing and Processing I don't like using lights because I think that this will take away from the natural appearance of a picture and so I'm always looking for the way that available light is falling and trying to see if there's some way that I can use this in my picture. Having an eye for light and shade can allow you to add so much to an image and those who work at it eventually will see how the light is working for them almost automatically.

Pointer I like to set my camera up on a tripod with a cable release, frame the picture and then step away from the camera. Then, armed with the knowledge of what I'm including in my frame, I can concentrate purely on the picture that I'm taking and the subject will be aware of my presence rather than me being hid behind the camera.

"You could tell that she wasn't used to being given anything this delicate because of the awkward way that she's holding it."

Tone, Texture and Contrast

Ethiopia 1991 by Dario Mitidieri
Nikon F4, 35mm Lens, Kodak Tri-X film.
Exposure 1/125sec at f/2.8

I was on assignment in Ethiopia, to photograph the country in the aftermath of 30 years of civil war. The dictator Mengistu had fled for Zimbabwe and left behind him his army of 600,000 soldiers, and they were now in a terrible state, still classified as military men and, as such, not even eligible for refugee status or help from organisations such as the UN. Consequently they were receiving just the barest of rations and were dying in their hundreds.

Many of them were in a camp in Tigre in the north of the country where the worst of the fighting had taken place, and I decided to go there to photograph their conditions. While there I saw this scene, as a woman prepared a basic meal for them. What made the picture so strong was the fact that I was shooting from inside a dark tent straight into the light. This made the woman, standing at the mouth of the tent, almost a silhouette, with just the tiniest amount of light catching the side of her face. As the smoke from the cooking rose it too became backlit and highlighted, creating a moody and atmospheric background through which some of the soldiers can just be made out to help place the scene.

Dario Mitidieri

Technique Because I wanted the woman and the cooking pots around her to be largely in shadow I decided to expose for the background and to let the foreground go dark. The result was a picture full of strong contrast that helped to capture the atmosphere of the scene in a way that a more traditional approach couldn't have hoped to match.

Pointer Often the most ordinary of scenes can be photographed in a particular way that will help to heighten the drama and to maximise the impact. There were several viewpoints Dario Mitidieri could have taken up around these cooking pots for example, but he chose one that was unorthodox and which technically broke the golden rule that says the camera should not be pointed towards the light source. The end has justified the means, however, and proved once again that the laws of photography are just there for guidance, not strict adherence.

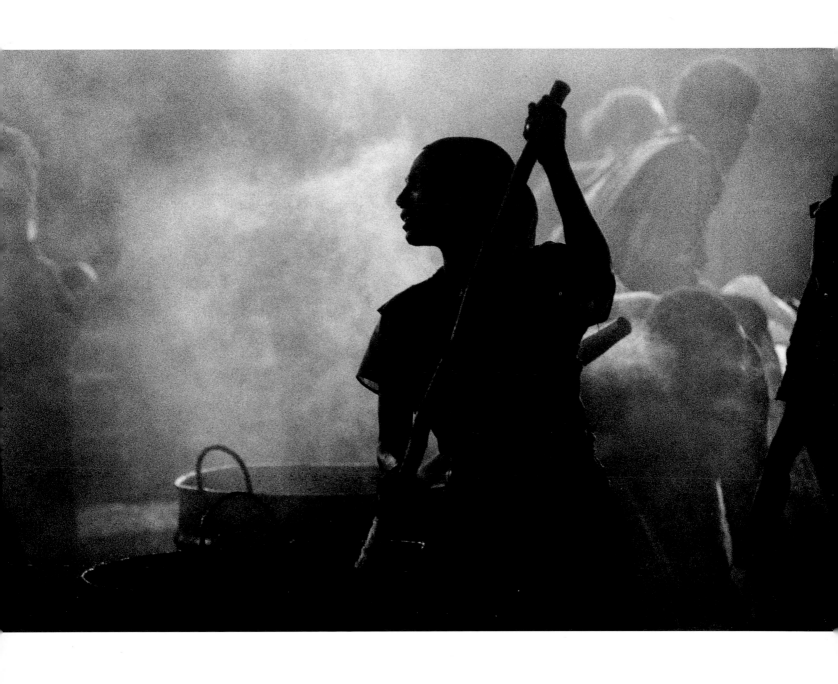

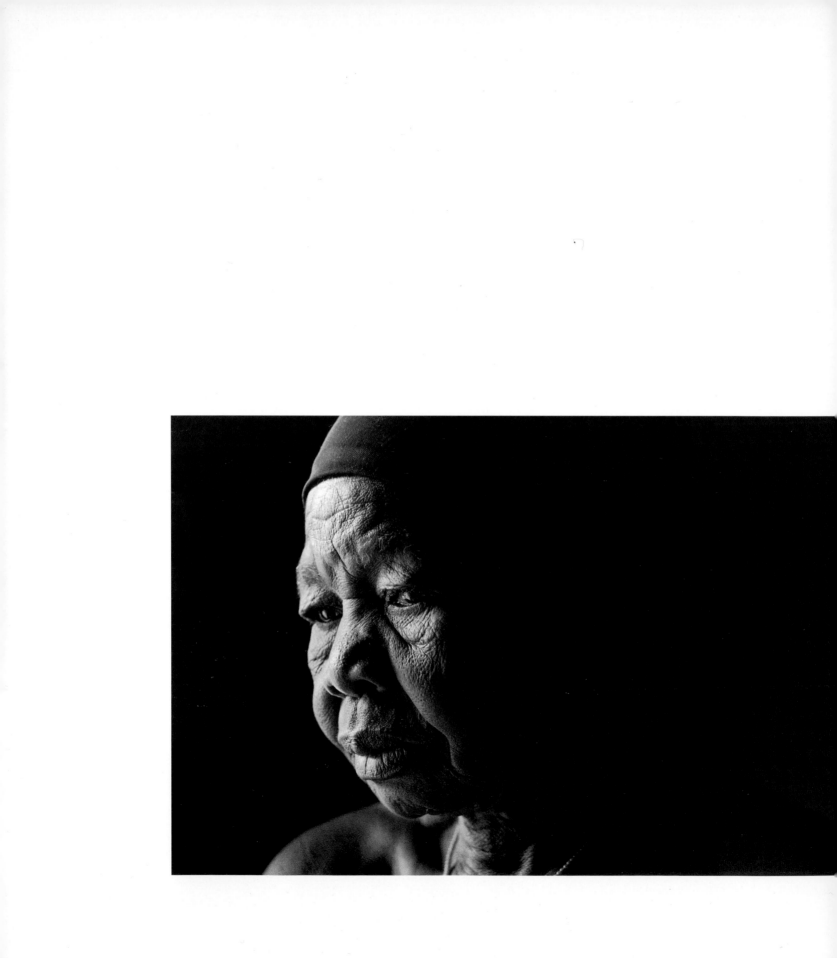

Tone, Texture and Contrast

Old Woman by Marj Clayton
Nikon FM2, 105mm lens, Ilford Delta 100.
Exposure not recorded

I took this portrait of an old woman in Northern Ghana and just saw the potential for the situation as she sat in the shade of a building, the light coming through the door highlighting her face against the deep shadows behind her. What this picture illustrates is the power of negative space at times. Although much of the picture is completely dark and has no detail at all, it still adds immensely to the picture and gives it its quiet and reflective mood. It's a picture that is very much about pure black and white far more than mid tones, the light hitting the face of the woman and bringing out the texture of her skin through the shadows that it's creating there.

This is the full frame that I took and so this is the balance of the image as I saw it at the time. I do tend to frame my images very tightly so that I achieve exactly what I want on the negative and no more, because I find that this is a good discipline and it also helps to ensure there's less need to enlarge the image and hence less grain. If you work that way, however, you have to be very precise because it is easy to crop just a little too tightly and then there's nothing extra that you can use to retrieve the situation.

Marj Clayton

My Favourite Tip I don't want to be too informed by the work of other people because I think that it's very easy to be influenced and to be reduced to copying. There are times, however, when I do feel that I need a little in the way of inspiration and then I'll get out the photographic books that I keep for moments such as this and will browse just for a limited time. I think the knack is to get ideas but to look at things in your own way, not to try to produce the same images yourself.

Pointer This is a relative of a friend of mine and I asked before I started taking pictures of her because I hate to steal a picture. In this case I took the picture without influencing it in any way: if I was looking at someone and could tell that just a slight adjustment of the pose would benefit the picture I might suggest that they move a little. Sometimes it's just a case of asking someone to look in another direction or to relate to someone else in the frame so those things look more natural. I'll also keep shooting because, as they begin to get used to me, they start to relax and the pictures become less forced.

"Although much of the picture is completely dark and has no detail at all, it still adds immensely to the picture and gives it its quiet and reflective mood."

Printing a

d Processing

The darkroom is the place where black and white really comes into its own, and where the creative process can be taken to new levels. Here the experts give a taste of what's possible

Printing and Processing

Old Spitalfields Market by Randall Webb
Nikon FE2, 35mm lens, Kodak 3200 T-Max film downrated one stop to ISO 1600.
Exposure 1/60sec at f/2.8

I decided to undertake a long documentary project to record the Old Spitalfields fruit and vegetable market in the city of London before it was moved to new custom-built premises in east London. The market had been established in the city since 1682 by Royal Charter and had become the centre of a very close-knit community. Many traders and porters spent all their working lives there, following in the tradition of their fathers and grandfathers. Most of the workforce came from the east end and included a wide variety of 'characters.'

The traders usually opened their stands at 2am and finished trading about midday. There was a break at about 6am for refreshments — either beer or rum and coffee at The Gun pub (the only pub to have a licence to serve alcohol at 6am onwards) or a greasy English breakfast at Dino's cafe. I used to arrive at the market sometime after midnight and leave mid-morning. My assistant and I spent two or three nights a week taking photographs for about two months. After a bit of initial suspicion, we were welcome to photograph anyone and anything we wanted to. Many of the people in the market bought photographs of themselves and their stalls as souvenirs before the market closed.

Afterwards, when the site was empty, the company who were about to develop it offered us one of the empty shops to use as a gallery from which to sell prints. This was free of charge and was part of a scheme to encourage shops to be occupied on short-term leases.

This picture of a market porter carrying vegetables on one of the traditional barrows was taken at around 3am. I decided to produce it as a limited edition salt print, using Fabriano Water Colour paper, which is hand made, as my base.

Randall Webb

Printing and Processing Because I was contact printing I needed to produce a larger negative and so I made a very low contrast print on to resin coated paper (low contrast to make sure that I recorded all the shadow detail) and then dried this. Then I contact printed this on to a sheet of lith film: resin coated paper is quite translucent and has no texture and so this process works quite well, and requires an exposure time of around 30 seconds. The lith film was then developed for two minutes in print developer to produce a continuous tone negative that had extra contrast, making it ideal as the starting point for a salt print.

To make the emulsion for the salt print you need to mix up a 2% solution of salt water by adding 20grams of sodium chloride (sea salt from the supermarket) to one litre of cold tap water. Pour this mixture into a clean developing dish and immerse the paper of your choice in it and let it soak for around five minutes, and then hang the paper up to dry overnight. Alternatively you could speed things up by letting the paper drain and then finishing the drying process with a hair dryer or a small fan heater. At this stage the paper is not light sensitive, so the operation can be carried out in daylight.

Next you need to mix two separate solutions. One is a mixture of 50ml of distilled water and 12 grams of silver nitrate and the other is 50ml of distilled water and 6 grams of citric acid. When both are completely dissolved mix them together and put the liquid into a small brown screw topped bottle ready for use. The citric acid acts as a preservative and stops the silver coating from darkening before you can use it.

Now you need to coat the salted paper with the silver. This needs to be done in subdued daylight or normal tungsten room lighting. Avoid working in a room with fluorescent light. Then apply the silver/citric acid to the paper with either a flat brush or a glass rod, and then dry the paper with a hair dryer or a fan heater. At this stage the coating is virtually invisible, so mark the back of the paper with an X so that you know which side is the front. Now take your negative, which will work best if it's contrasty, and place it dull (emulsion) side down on the coated side of the paper. Place this sandwich in a printing frame and then place this, glass side up, in daylight or sunlight or under an ultraviolet lamp. Within a few minutes the silver coating outside the edges of the negative will darken. At regular intervals of three or four minutes (more like once every minute if using the sun as the exposure source) unclip one part of the hinged back of the printing frame and check the progress of the printing, taking care not to move the negative and print out of register.

When the print is exposed to the point that all the tones are correct, and the highlights have sufficient detail, take the frame out of the light and remove the print. If everything has gone to plan, you should have an image that is a rich reddish brown and, if you've used the brush method of application, as here, you'll also have an irregular dark border caused by the silver being brushed outside the confines of the negative.

The print now needs to be processed. In subdued daylight or tungsten room lighting place the exposed print face up in a clean developing dish and wash it in running water. The unused silver nitrate will turn the water slightly milky, and when this disappears – usually after about four to five minutes - the washing is finished. Then make up a fixing bath consisting of 500ml of cold tap water, 25 grams of sodium thiosulphate powder and 2 grams of sodium carbonate, and immerse the print face down in this for about five minutes. The colour of the print will change in the fixer to a somewhat unattractive ginger brown colour, but it will revert to its original colour when it is washed and dried. When fixing is complete wash the print for 30minutes in running water, remove excess moisture with a sheet of blotting paper and then hang the print up to dry naturally. The finished result should be stable enough to use and display in the conventional manner.

Technique Coating the paper is relatively simple, but will need practice. To brush the emulsion on, as I did here, take your sheet of paper and attach it to a flat piece of hardboard with a strip of masking tape along each edge to hold it flat. Now take the negative and place it on the paper and very lightly mark where you want its position to fall. Now take the saucer containing the emulsion, and dip into it with a flat paint brush (the best are flat wooden handled 'hake' brushes from any good art supplier) about one inch wide, taking care not to overcharge the brush. Then brush the emulsion onto the paper within the area where the negative will fall, taking care to be gentle to avoid abrading the paper's surface. The paper should absorb the liquid to the extent that, when you look across the surface of the paper, no pools of liquid remain. At this stage you can carry the liquid across your markings to give a small margin of brushed emulsion with a ragged edge. When exposed this will give you the brushed edge that is characteristic of so many old process prints.

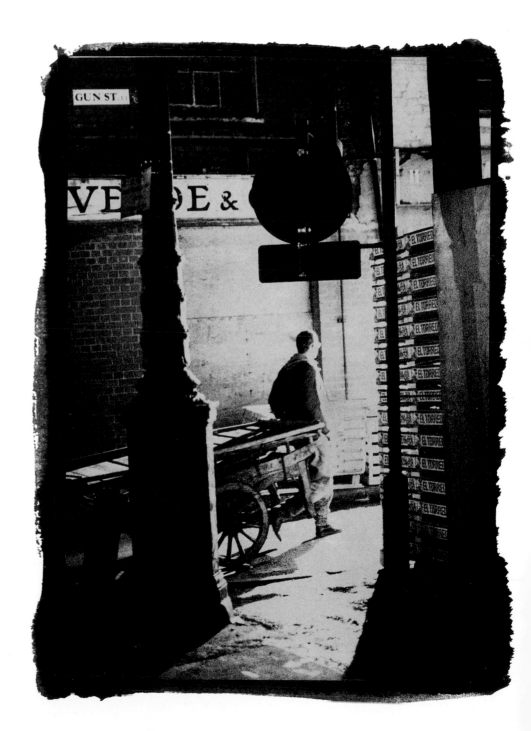

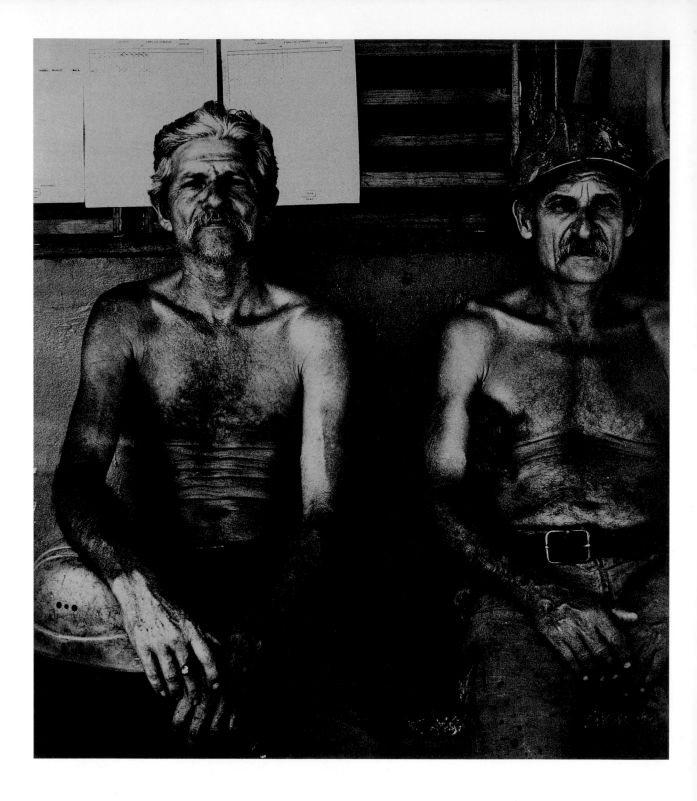

Printing and Processing

Cuban copper miners by Allan Jenkins
Mamiya C330 6x6cm camera, 80mm lens, Ilford HP5 film.
Exposure 1/60sec at f/5.6

Because I'm fluent in Spanish I was asked by a delegation of the National Union of Mineworkers to accompany them to Cuba, where they were due to present the workers at a copper mine there with a huge container full of donated equipment, such as helmets, boots and lamps. It was a gesture that was really appreciated, because Cuba at that time was not allowed to import or export any goods and the equipment that they were using at the mine was archaic to say the least.

I was still at college at the time and had no official role as a photographer, but I decided to take along my medium format camera to see if there was any opportunity to take any pictures. As it turned out I was lucky: because I was attached to the delegation I was accepted by everyone and all those that I asked to photograph were happy to oblige, looking into the camera with very deep and soulful eyes.

These men were about to go into the pit to start their six-hour shift and I was very taken with their strong and characterful faces and their calm and poised manner. It almost looked like a scene from a hundred years ago and I decided that it would be a perfect series of portraits to marry with the vintage printing process that I was starting to experiment with at the time.

Allan Jenkins

Printing and Processing I specialise in a Victorian process known as Cyanotype printing, which gives my pictures a vintage and quite timeless feel, and I've added my own touches to produce a finish that is uniquely mine.

I start with heavyweight 300gsm Arches Platine water colour paper that has been 'seized,' ie sealed, on one side so that it will take the coating of chemicals that I need to give it. Then I mix up my emulsion: I add 9gms of Ammonium Ferric Citrate to 50ml of water to make one solution and 4gms of Potassium Ferro Cyanide to another 50ml of water to make the other. These are then mixed together in equal quantities, at which point they become sensitive to UV light and need to be kept in a brown glass bottle to prevent deterioration.

I apply the liquid to the paper with a hake brush that contains no metal — metal would affect the ferric salts - and allow it to dry. It's even possible to use a hairdryer to speed this up, and once the drying process is complete I can make the print. Because this is done through contact, the print will be the same size as the negative, and so if I want something bigger than 5x4in I'll produce an internegative — a new negative produced to the size I want the print to be — to work from. The print needs to be exposed under UV light, which creates a chemical reaction. When the print is subsequently washed it oxides the ferric salts that have been exposed and removes those that haven't been affected, ie those that have been protected by the darker areas of the negative. When dry the print is a Moroccan Navy Blue in colour, and my touch then is to tone this with tannic acid , a process that stains and mutes down the highlights and lifts the shadows, creating a more uniform tone.

"These men were about to go into the pit to start their six-hour shift and I was very taken with their strong and characterful faces and their calm and poised manner."

Printing and Processing

Miner in the Ukraine by Adam Hinton
Leica M6, 50mm lens, Fujifilm Neopan 1600 uprated two stops to ISO 6400.
Exposure 1/30sec at f/2

I wanted to follow through a project that looked at the 'heroic' industries in the old Soviet Union after the collapse of communism. Miners had been well paid heroes of the proletariat under the old system and, from thinking that the system would never change, they were now having to adjust to the fact that, almost overnight, it had all collapsed.

I managed to arrange to stay with the family of a miner who worked at the Sals Dombas Mine which was near Donetsk in the Ukraine, and I visited them eight times over a period of about three years. Eventually my project changed from being purely a documentary on the miners to being a story about the life of this one particular mining family.

This was a portrait of a friend of the family that I took quite early on in the project during a trip I made underground. It was completely pitch black and it was almost impossible to work in any kind of structured way. I knew that I wanted a strong portrait like this, however, and so I worked to set it up, asking a few of the other miners who were there to position the lights on their helmets so that there was as much illumination in my subject's face as possible. I also pushed the film I was using, Neopan 1600, two stops to try to squeeze as much out of the scene as I could.

Adam Hinton

Pointer In a situation such as this where you don't speak the language there is, of course, an amount of awkwardness because it's impossible to put across in words exactly what you want. There is a plus side, however, because it keeps you one step away from everything and makes sure that you can't interfere too much in what's going on, and that can be helpful in terms of you becoming an observer rather than being tempted to become more involved.

Print and Processing Adam Hinton's printer Gary Wilson explains how he achieved this final result. "It was quite a straight print," he says, "but there was some degree of dodging and burning required to even out the contrast.

"I printed on Ilford Multigrade fibre based paper and set the enlarger's filtration to produce the equivalent of a grade 3 1/2 paper, which was about one grade up from my normal setting. I like to treat portraits this way because I think that it gives them more punch.

"The base exposure was sixteen seconds and I held back the eyes and the left hand side of the face for a few seconds of this to make sure that these areas were nice and bright. Then I needed to burn in the miner's lamp and the front of the helmet, where there was intense highlight detail. I estimated that this area required three times the base exposure and I achieved this while shielding the rest of the printing paper by making a small tool, which was basically a hole roughly torn in the middle of a sheet of opaque card. By holding this between the enlarger lens and the print and moving it continually, I could add the extra exposure to exactly those areas that required the treatment.

"I decided to drop the grade for this part of the exposure however, changing the filtration so that the burning in was carried out with the paper reacting like a grade two. If you burn in on a higher grade it can be quite noticeable because the shadows will get much darker, while on a lower grade the shadows are not affected so much."

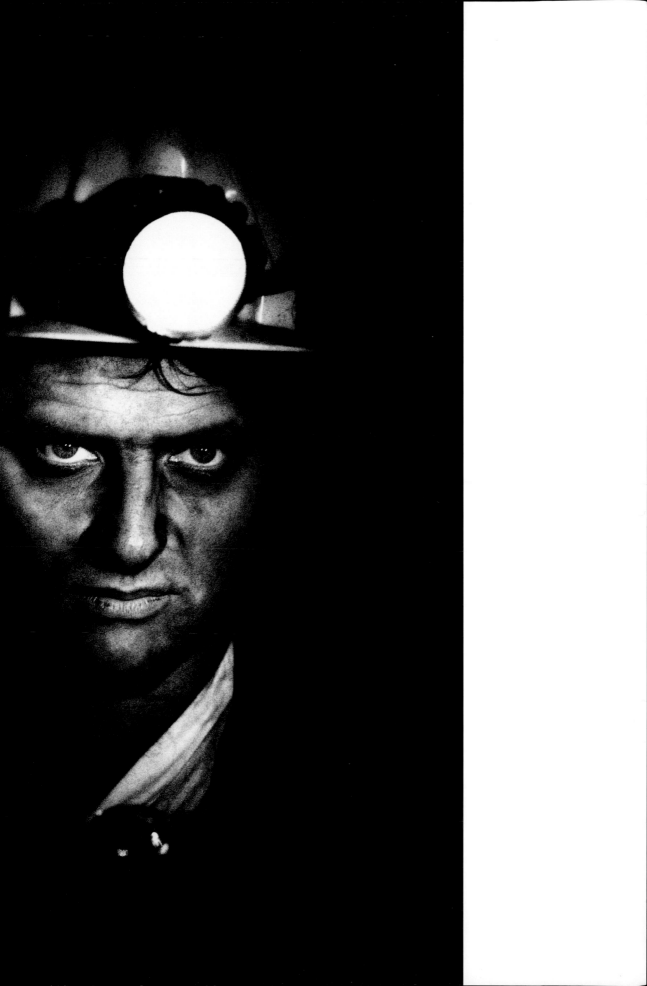

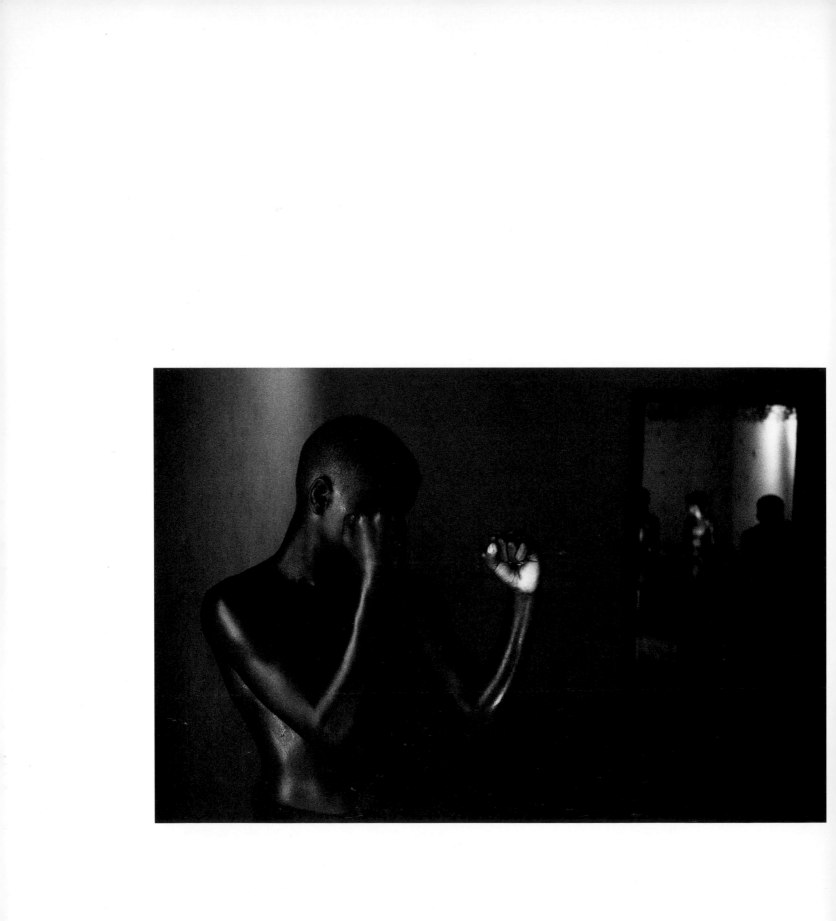

Printing and Processing

Boxer in Cuba by Adam Hinton
Leica M6, 50mm lens, Fujifilm Neopan uprated one stop from ISO 1600 to 3200.
Exposure 1/30sec at f/2

While on a personal assignment to Cuba I spent a lot of time in the boxing gymnasiums in Havana and, while there, I set up this portrait of one of the young boxers who was training in a room that was almost devoid of light. The only illumination reaching him was coming through a door that was behind me and this was reflecting from the sweat that had built up on his body, creating just small areas of highlight all around him, and a further small area of highlight on the wall behind.

The only other detail in the room was a mirror hanging on the wall to his right, which is reflecting back ghostly images of some of the other boxers standing behind me. It's a detail that I really like and I think that it adds to the picture immensely.

Adam Hinton

My Favourite Tip I never use the camera light meter to calculate exposure because I don't think that it will ever be accurate enough. People think that black and white film has enormous latitude, but that isn't true. Anything more than a stop either side of the exposure you need and the quality will suffer, so I always take a reflected light reading from a hand held meter and work from that.

Pointer This Adam Hinton picture was printed by Gary Wilson, who used all his expertise to emphasise the dark figure of the boxer against the surroundings that could so easily have enveloped him.

"The tone between the boxer and the background was very close," he says, "and my task was to try to make sure that the two were separated. The main way that I did this was to use a grade five Ilford Warmtone fibre based paper and I had to make sure that my base exposure was absolutely spot on, because even a second or so the wrong way would have either increased the shadow to an unacceptable degree or made the result appear flat and grey. The exposure I gave was 20 seconds and then I had to add exposure to certain areas to equal out the contrast. The area in the top of the mirror, for example, required a further ten to 12 seconds and I also decided to add a few seconds exposure to the heel of the boxer's hand, which was very bright. Then I burned in all around the edges of the print to make sure that a good density was achieved there.

"I wanted as much contrast as possible throughout the print and achieved a little extra by making the Speedibrews D163 developer that I was using rather warmer than usual – 25 C rather than 20 C – and then I underdeveloped the print a little, pulling it out of the developer and immersing it in the stop bath as soon as the black tones had appeared. This achieved something like an extra half stop of contrast, which was just about enough to give the print the tonal separation it required."

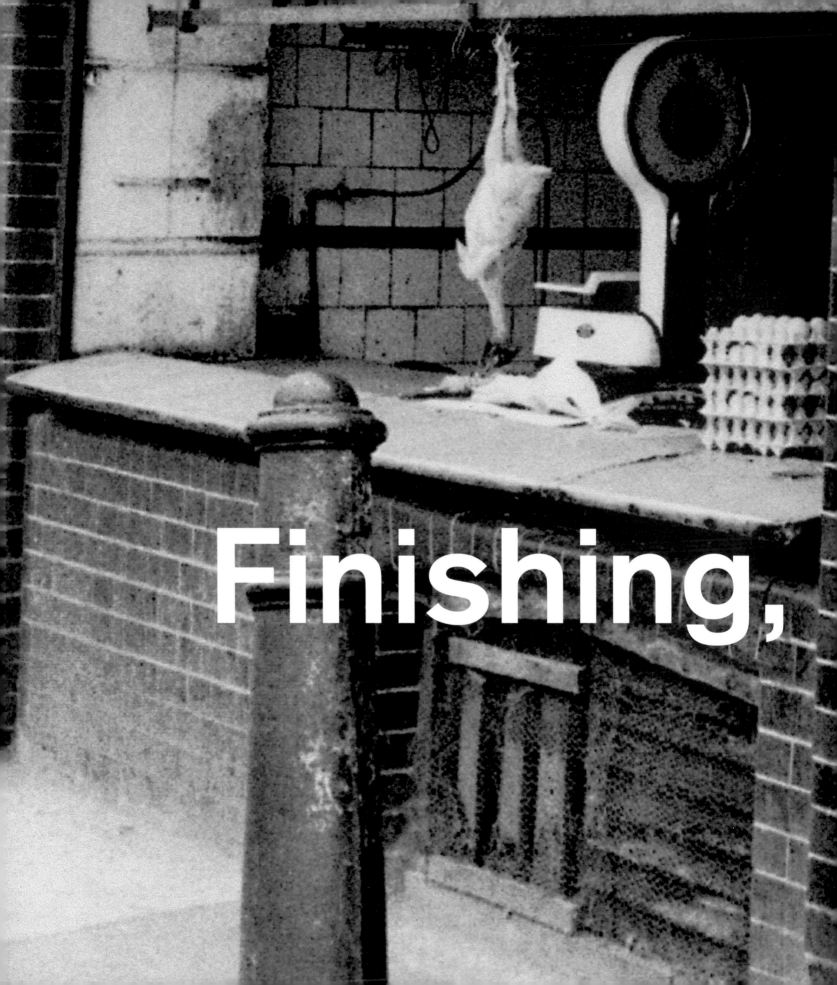

Finishing,

Exhibiting and Websites

You've taken and printed your picture, and now it's time to show it the world. Thanks to the Internet the display possibilities that exist are wider than ever before, and this section gives advice on how to make sure that you're doing your pictures justice when you present them

Back to back houses in Birmingham by Bert Hardy
Rolleiflex 6x6cm camera, fixed 75mm lens.
Film and exposure not recorded

Bert Hardy/Hulton Getty

It's amazing how often photographers put maximum effort into the production and printing of a picture, only to neglect the final framing and mounting stage. And yet the presentation of a picture is a vital part of the whole process, and it's entirely possible that a picture could lose much of the impact that the photographer has worked so hard to achieve simply through lack of care in its finishing.

If you want your picture to last and to be shown off to best effect, there are certain key steps to follow. At the printing stage it's extremely important to ensure that fixing and then washing is extremely thorough. Toning can also add to the permanence of an image: a light Selenium tone is used by many printers, because this has little effect on the normal black and white tones, but helps to make them more stable. Tones such as Thiocarbamide and Sepia will also add to a print's archival qualities, and the colour they add to a picture is often beneficial as well.

Once a print has been washed and dried, it should be carefully spotted with archival inks to make sure that there are no dust marks or hairs visible. The picture is now ready for mounting.

Mounting The job of the mount is to set the picture off, and to create an area around it that is plain and unlikely to distract. The width of this mount is down to personal choice, though some pictures that are printed as miniatures often benefit from a wider surround in ratio than prints that are larger. Keep the colour of the mount neutral – with black and white images white or light cream is the usual choice – because it will then be able to carry out its job efficiently and well, and the picture itself will remain the centre of attention. Great care needs to be taken over the cutting of the mount: generally specialist tools are required to ensure that a smooth bevelled edge is created. If you try to cut a mount using just a scalpel and a steel edge, the chances are that it will look messy and that you will slice through at least one or two fingers. Visit an art shop and ask for advice from the staff there, and they will recommend the equipment that you need.

The Print Room at the Photographers' Gallery in London handles thousands of valuable photographic prints every year, and often arranges the framing and mounting of pictures for purchasers. Print Manager Fiona Duncan explains the policy on mounts: "Generally when we sell a print," she says, "we mount it in archival acid-free board. One board is used as the backing board, and on this we create three small pockets from archival tape, and these hold the print gently in place. The print doesn't need to be fastened any more securely than this, and this method allows it to be removed easily at a later date if required.

"Then a window mount needs to be cut so that it frames the picture, and this is connected to the backing board along one long edge using archival tape. This means that it's effectively hinged and can be brought across the picture, and then the picture is ready for framing."

Framing Once again frames are a matter of personal choice, but often it's those that are the simplest in terms of design and colour that work the best. A black frame, for example, can look stunning when it's surrounding a classic black and white picture, whereas one that features a strong colour or an intricate design will start to fight the picture. "The only other colour apart from black that might work on occasion, particularly with vintage black and white prints, is gilded silver leaf," says John Dawson, a Director of John Jones Frames, who carry out much of the framing for the Photographers' Gallery Print Room.
"We would normally suggest that frames shouldn't be more than 1/2 inch wide for pictures up to around 20x16ins, while above that size the width can rise to 3/4 inch without becoming too dominant. The mount should ideally be around three inches in width increasing to three and a half inches at the bottom for prints up to 20x16ins, and again this can rise a little, to four inches perhaps, for larger prints."

The final stage of the framing process is the selection of glass and, for archival purposes, you should select a material that offers UV protection, because this will give your print a longer life, particularly if it's going to be hung in a room that attracts a lot of daylight.

John Jones Framing Department can be contacted on 020-7281 5439

Butcher's Shop, Stepney East by John Claridge
Pentax S1 SLR, 50mm lens, Kodak Tri-X film.
Exposure 1/30sec at f/11

I wanted the project that I was producing on the east end of London (see The Photo Essay) to have as much diversity as possible, but I never set out to take any specific images. I simply walked around and kept my eyes open for scenes that I knew, even if it was only subliminally, were likely to be lost in the years to come.

This picture was taken in 1966 in the Stepney East area and when I first saw this shop I knew it would make a fantastic subject. It looked great: it was full of character and was a real symbol of the face of the east end that was changing rapidly at that time and so I went in and asked the two brothers who ran the establishment if they would mind posing for me. They agreed and simply walked to the door and stood there, and this is exactly as I saw it.

Needless to say the shop, along with great swathes of the area, has long since disappeared, with supermarkets and tower blocks now the new face of this part of London. The community feel had changed completely within ten years of me taking this image and I'm glad that I took the time to keep a personal record of it.

John Claridge

Exhibiting John Claridge held his first show of work, which consisted of early images from his east end series, in 1961 at the McCann Erickson Agency in London at the tender age of 17! "All kinds of people, including VIPs from the US and Europe were passing through and they were looking at my work, and it was a really good feeling," he says. Since that time he's shown his work on a regular basis and has also self-published three books: along with 'One Hundred Photographs,' a selection of personal and commercial work, he's also produced 'South American Portfolio,' a selection of personal black and white and colour photographs and 'Seven Days in Havana,' a set of black and white images shot within a specifically defined time frame in the Cuban capital. Further projects are in the pipeline and John finds it a useful way of stretching his creative muscles and of showing work that is free from commercial constraints.

"An exhibition or a book is a really good way of putting yourself on the line and saying to people 'look at this,'" he says. "When I was starting out I got tremendous inspiration and pleasure from looking at work from the likes of Walker Evans and Bill Brandt and that's what it's all about really. It's showing something that is special to you and hoping to get a reaction from the people who have made the effort to go and look at it."

Pointer Putting together an exhibition is one of the most satisfying ways of using your pictures, whether it's a show at a major gallery that you're putting on or a small display at your local library. Before you even start you have to make sure that you're really ready to go public: a theme for your work is essential, and, like John Claridge, you must be sure of your own style, because work that's too derivative will be found out immediately.

Making the right selection is the next problem: producing rough prints will help you to see how your pictures work together, and it will give you the chance to get feedback from those whose opinion you trust. In the final analysis, however, you must have the confidence to make your own decisions about what to include, otherwise the exhibition will end up being selected by committee. John is very single-minded about his work and lives or dies by his intuition: "It's all personal choice and it's up to others whether they agree with my selection," he says. "The only person I discuss it with is my wife Janet because I always have too many pictures and have to make decisions about what to include. But I know what I want to say and it's up to me to make the right choices."

Websites

www.davidmodell.com

Introduction Set up a personal web site and you've established an exciting and cost effective way of showing your photographs to a potentially unlimited worldwide audience. Best of all, you'll be in charge of the content and the presentation, and so you have far more freedom to express yourself than you would normally expect from a conventional exhibition outlet. All you need is around 10Mbytes of web space from an Internet Service Provider (ISP), usually your internet provider. This service is generally free, and you'll be able to show a large selection of your favourite images, together with any accompanying words you want to include.

What You Will Need The first essential piece of equipment you require is a computer. The very minimum would be a Pentium 160 with Windows 95. Whatever computer you decide on should have at least 32 megabytes of RAM. (Do remember though, your hard drive i.e. amount of space on your computer, will slowly be eaten up the more programmes you load, which will in turn slow down each action you do). You'll find extra RAM really useful when scanning and editing.

Next you will need a scanner. There are lots on the market and most will do the job. Please note though, the image that will appear is only as good as the resolution of the computer screen displaying it, so it's no good scanning at the highest resolution of your scanner thinking you will get a better displayed image. Typically, screen resolution is 72-96 pixels per inch (ppi). Also, the greater the size of the image, in megabytes, the slower it will take to appear (download) on the internet. The good news for those working in black and white is that mono images will download approximately eight times faster than a colour one.

Once pictures are scanned, you can alter them on an image-editing programme, and PhotoShop is widespread. The capabilities of such programmes are vast, but at a simple level, you could create electronic frames and borders, lighten, darken, change image sizes or add a tone. Additionally, you could watermark your images i.e. give them an electronic signature that says they are yours. Although you cannot stop people copying your images from the internet, at least if they appear again, they are watermarked. Remember to save your image: the internet supports gif or jpg, e.g. yourimage.jpg.

As previously mentioned, the time it takes an image to appear over the internet is a function of its file size. For a benchmark, colour images should be approximately 80Kbytes in size, while black and white should be an 1/8th of the file size, when based on an image measuring about 5 cm x 3 cm. It can also be useful, however, to show very small images, known as thumbnails, because these will download in a fraction of the time. Then, if people are more interested and want to see more detail, they can click on the thumbnail, by use of a hyperlinkA, and a larger version will download. People will be more prepared to wait for something they asked for, but for this system to be effective you'll need to put a meaningful title against the thumbnail.

www.in-public.com

Now you need to add some text to your pages. If you want to
bring text and images together, but don't want to learn pure
HTML, you can use programmes such as Front Page or Page
Maker, which are simple drop and drag web-editing programmes.

Each page you complete needs to be saved as a htm file, e.g.
mywebpage.htm, and the first page of your internet site has to
be called home.htm, i.e. your home page.

How will I advertise my site? How will I get visitors?
Difficult one! Just type in 'photography' into any search engine
and see how many sites exist. So how do you get ahead of the
competition? Placing adverts in journals can cost an arm and
a leg, but there are electronic ways around the problem. For
example, you could find a popular site that would complement
your own, contact them and then ask whether they will include a
link to your site. If you feel like writing some web code (HTML),
you can also incorporate the META TagsA, which are key words
that define your web page, in terms of HTML.

Finally, remember to include your e-mail address on your web
site, so that if anyone sees your pictures and wants to contact
you about them, all they have to do is to click on your address.
 Debra Palmer

Biographies

Bryn Campbell was introduced to photography in the 1950s and became Assistant Editor of the title **Practical Photography** in 1959, leaving to edit **Cameras** magazine the following year. After a period at **The British Journal of Photography** he helped to launch the **Observer Colour Magazine** in 1963 and then became Picture Editor of **The Observer** between 1964-66. From 1966-1972 he was a freelance photographer retained by **The Observer** and, following this, he spent a year completing his Village School project. From 1972-1984 he was a freelance writer and photographer and since then he has been Picture Editor at different periods of the **Sunday Express Magazine**, **The Illustrated London News** and **The Daily Telegraph Magazine**. He now freelances once more as a writer and photographer. Awards include a First Prize (News) in the British Press Pictures of the Year contest in 1969, a Kodak Bursary in 1973 and an honorary associate lectureship in photographic arts by The Polytechnic of Central London from 1974-1977. He wrote and presented a six-part BBC TV series **Exploring Photography** in 1978, was a member of the Arts Panel at the Arts Council of Great Britain from 1980-1983 and was a British judge for the World Press Photo in 1985. He has published many books, the latest of them, **The Imprecise Image**, which featured experiments in colour photography, in 1995. He has also had several major one-man exhibitions including **Retrospective** at The Photographers' Gallery in London in 1973, **Village School** at the Chichester 900 Festival in 1975, **Antarctic Expedition** at the Olympus Gallery in London in 1980 and **Colour Retrospective** at The Photographers' Gallery in 1981.

John Claridge was born in 1944 in London's east-end and, from the age of 15 to 17, he worked in the photographic department of a London advertising agency. He decided early on that photography was his vocation, holding his first one-man show at the age of 17, and then working as assistant to American photographer David Montgomery for the next two years. He opened his first studio aged 19 in London's City area, and since that time he's worked for most leading advertising agencies and clients in Europe, the USA and Japan. His work has been exhibited world wide, and he's been presented with over 500 awards for photography, both editorial and commercial. Selected pictures have been auctioned at Christie's in London, and his work is also held in the permanent collections of the Victoria & Albert Museum in London and The Arts Council of Great Britain Archives. He's published three books: **South American Portfolio** (1982), **One Hundred Photographs** (1987) and **Seven Days in Havana** (2000).

Marj Clayton was born in Canada in 1965. At age 12 she began photographing when her father lent her an old 35mm Pentax spotmatic. Under his instruction she learned the importance of lighting and composition as well as how to process and print. Her father stressed the need to 'get it right in the camera' and to 'fine tune' in the darkroom. By 1983 she began formal training in photography at 'The Confederation College'. After completing this course she spent four months living, working and photographing in rural Bolivia. An Arts Council grant enabled her to return to Bolivia for six months in 1990. Her most recent visit to Bolivia was for a year in 1995. The success of the Bolivian series inspired her to visit Ghana on two occasions making images on farmers. Marj enjoys getting to know her subjects and believes the friendship she shares with her models is the key to accurately portraying their lives. She has most recently, just returned from two visits to Chile and Bolivia, the latter on a book commission for Oxfam, and hopes in the future to expand her work by visiting other African countries. "My images are about people, the things that make them unique, the environment they live in and their way of life; the things, pastimes, or other people, that make it all worthwhile for them."

35 73

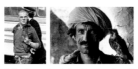

John Downing left school at 16 and took up an apprenticeship with the **Daily Mail**, leaving in 1957 to freelance for the **Daily Express** as a photographer. In 1964 he became a staff photographer at the newspaper and then he became the chief photographer in 1985. Major news events covered during his time at the **Express** included Vietnam, Beirut, The Falklands, Nicaragua, Afghanistan, The Gulf, Bosnia, Somalia and Rwanda. In 1984 John was a founder member of the Press Photographers' Association, set up to promote the quality of press photography in the UK. He was made a Member of the British Empire in 1992 and given a Lifetime Achievement Award by the Picture Editors' Awards in 2001. Other awards include the Rothman's Press Pictures of the Year in 1971, runner-up (news feature) in the World Press Photo in 1972 and 1978, Ilford Press Photographer of the Year in 1977 and 1980, UN Photography Gold Medal 1978, Photokina Gold Medal 1978, Martini Royal Newspaper Photographer of the Year in 1990, Kodak Features Photographer of the Year in 1992/93, runner-up in the Photographer of the Year section of the Picture Editors' Awards in 1994, 1995 and 1999 and La Nation (Argentina) International Photographer of the Year in 1994-1995.

19 78

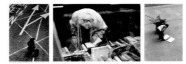

David Gibson has been involved in photography for more than ten years. His photographs have appeared in **The Guardian** and he is a contributor to several prominent stock libraries. His work is also held in numerous private collections. Extended portfolios of his work have featured in magazines such as **Amateur Photographer**, **Baseline** and **Photographers' International**. He is part of a collective of like-minded street photographers whose work can be seen on www.in-public.com.

43

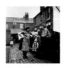

Bert Hardy was one of the UK's most distinguished photojournalists, and for many years was the chief photographer for the legendary **Picture Post** magazine. Born in 1913 near Blackfriars, he never lost touch with his working class south London roots. Very much self taught, he was an early user of the Leica 35mm rangefinder camera. He and other forward-thinking photographers of that time made full use of the flexibility and miniature size of the new format to produce pictures that captured action in a way that had never been seen before. His pictures of the poor areas in various cities are among the most powerful of their kind, and he was one of the first photographers to enter Belsen after its liberation, the most shocking experience of his life. Bert grew to fame during the Korean War, when his daring pictures of the Inchon landings won him many awards. Later he shocked Britain and America with his pictures of the ill treatment of prisoners of war. After the close of **Picture Post** in 1957, Bert carved out a second career, as an advertising photographer, and he brought the versatility of the 35mm format to this area as well. He produced one of the most memorable advertising pictures of the era, the shot of a man at night standing on Albert Bridge in London that ran with the slogan 'You're Never Alone With a Strand.'

Biographies

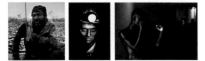

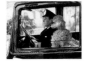

Adam Hinton has a multitude of photographic awards and distinctions to his name. He achieved a BA (Hons) Degree in photography at Trent Polytechnic in 1988, and since that time has worked for a number of major clients in the advertising and corporate sectors, such as the Midland Bank, Boots, Ericson, Canon, the BBC, Texaco, the AA, Coca-Cola and Eurostar. He's also undertaken a number of major commissions for newspapers such as the **Daily Telegraph**, **The Sunday Telegraph**, **The Observer** and **The Times**, and magazines such as **Newsweek**, **The Telegraph Magazine**, **Stern**, **Der Spiegel** and **The Independent Magazine**. His awards have included being named a finalist in the 1998 Ilford Awards and the 1995 and 1996 Fuji Art Awards and being selected for the Association of Photographers Personal Series in 1995 and 1997. He gained a Merit in the Association of Photographers Personal Series Section in 1994 and a Silver in the same competition's Commission Series the same year, and was named Young Photojournalist of the Year in 1991. He has also exhibited widely, at celebrated London venues such as the Association Gallery, Hamilton's Gallery, the Photographers' Gallery and the National Portrait Gallery.

Thurston Hopkins was one of the exclusive group of photographers on the staff of **Picture Post**. During his years with the magazine he carried out major assignments in all parts of the world, besides looking also at aspects of British life. His photojournalism twice won awards in the annual **Encyclopaedia Britannica** contests and examples of his photography are in many public collections, including the Victoria & Albert Museum, the Arts Council, The Museum of London and the Metropolitan Museum of Art in New York. Thurston Hopkins' work is discussed in numerous publications including **Photography in the 20th Century** (Tausk, 1980), **Post-War Europe** (Monreal, 1955), **A History of World Photography 3rd Edition** (Rosenblaum, 1997) and **The Photography Book** (Phaidon Press, 1997).

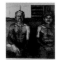

Allan Jenkins is a purist and a traditionalist, working only with natural light and using old-fashioned alternative non-silver processes. These methods were first practised in the 1890s, combining ferric salts and carefully exposed UV light, which cooks the images slowly into the fibres of the paper through the density of the negative. Allan's work is dark and mysterious; every print a curious mixture of new and old. He describes his pictures as "a fusion between painting and photography, joining forces as an art form influenced by traditional and classical art." Allan is represented by the HackelBury Fine Art Gallery, 4 Launceston Place, London, W8, tel: 020-7937 8688.

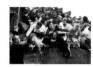

Eamonn McCabe is one of the most respected photographers and commentators of his generation. He studied film at San Francisco State College in 1969, and became a photographer with **The Guardian** in 1975, leaving to work for **The Observer** in 1977. He stayed there until 1986, picking up an unprecedented string of awards as a sports photographer in that time. He was named Sports Photographer of the Year no less than four times, in 1978, 1979, 1981 and 1984, and was News Photographer of the Year in 1985. He was named Official Photographer for the Pope's visit to Britain in 1982, and then became Picture Editor of **Sportsweek** magazine in 1986. From 1988 until 2001 he was the Picture Editor of **The Guardian**, a position he left to become a freelance photographer specialising in portraiture. During his spell at **The Guardian** he was voted Picture Editor of the Year by his peers in 1992, 1993, 1995, 1997 and 1998. He was the Fellow in Photography at the National Museum of Photography, Film and Television in 1988, and was made a Fellow of The Royal Photographic Society in 1990, and an Honorary Professor at Thames Valley University in 1995. He's exhibited at the Photographers' Gallery and the Barbican Gallery in London, and at the National Museum of Photography in Bradford, and has three books of pictures to his name. He can be contacted via e-mail on: eamonn.mccabe@freeuk.com.

20 23 24 24 39 88 95 111

114

Dario Mitidieri was born in Villa d'Agri, Italy, in 1959. In 1981, he moved to London, where he studied Photojournalism at the London College of Printing. He started to work as a freelance photographer for **The Independent Magazine** and **The Sunday Telegraph** in 1986, and since then his work has been published and exhibited worldwide. His major photographic assignments include: the plight of the Kampuchean refugees in Thailand; the Tiananmen Square massacre; German reunification; the cyclone in Bangladesh; the fall of the communist regime in Albania; the destruction of the Ayodhya Mosque in India and the subsequent communal violence in Bombay; Ayrton Senna's last race in Italy; the refugee crisis in Rwanda; the Kobe earthquake in Japan, 'children at war' in former Yugoslavia, Ethiopia, Rwanda and Angola; Charismatic Evangelism in the USA, England, India and Korea. He is currently working on a project on Ibiza. In 1992, he spent the whole year in Bombay documenting the lives of street children. This project resulted in the publication of the book **Children of Bombay**, 1994 (six editions across Europe). He is also the author of the books **L'Ultimo Ayrton**, 1995 (about Ayrton Senna's last Grand Prix, published by Giorgio Nada Editore, Italy) and **People and Railways**, 1997 (about the railway industry in Italy, published by Peliti Associati, Italy). Mitidieri is the recipient of numerous awards, including: Photographer of the Year, UK 1989; W. Eugene Smith Award in Humanistic Photography, USA 1991; Visa d'Or, France 1993; Premio Fotografia Periodistica La Nacion, Argentina 1993; European Publishers Award for Photography, 1994; Nikon Photo Essay of the Year, UK 1996; Leica - C.F.P. Photo Award, Italy 1998. Dario Mitidieri has also undertaken major corporate and advertising campaigns for clients such as: Barclays; Ericsson; Jockey; Italian Railways; Sony; Territorial Army.

36 82 96 107 108

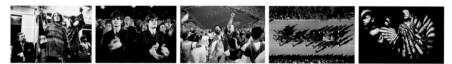

David Modell was born in London in 1969 and dropped out of school to pursue a career in photography at the age of sixteen, trying to sell news pictures to small London magazines. When he was eighteen he became a full-time freelance photographer on the **Sunday Telegraph**, lying at the time about his age in order to be taken more seriously. Soon he began to get interested in working on photo-stories, which he found more satisfying than shooting single images for newspapers. After a couple of years he left the **Telegraph** and began working on longer assignments funded by magazines. At one time or another his work has appeared in almost all major international publications. During his photographic career he has covered a huge range of diverse subjects such as the Irish Fans at the '94 World Cup Finals, the Bombing of Oklahoma City and the nation's response to the death of Diana. His personal project on the relationship between politicians and the media has encompassed the major UK political parties and the Clinton White House. Over the last six years he has documented the turbulent history of the UK Conservative Party in a humorous and sardonic way. These award winning photographs have been published in a book called '**Tory Story- a photographic essay by David Modell.**' David has won many photographic awards over the years including two World Press Photo awards- possibly the highest international accolade in the sphere of photojournalism. In 1997 he was awarded Nikon Photographer of the Year the UK's premier award. His work has also been displayed in several high profile exhibitions in many different countries.

Biographies

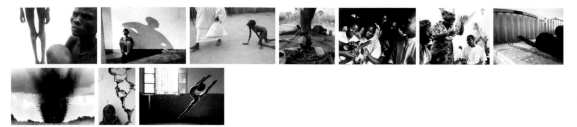

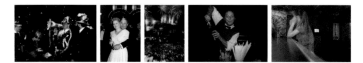

Tom Stoddart began his photographic career with a provincial newspaper in his native north east of England and in 1978 he moved to London and, working as a freelance, his pictures soon began appearing regularly in national newspapers and magazines. His assignments have been many and varied; in 1982 he was in Beirut as the Israeli forces bombarded Yasser Arafat's besieged PLO base. Later he was aboard the Greenpeace 'Rainbow Warrier' as the environmentalists campaigned to stop Canada culling baby seals in the Gulf of St Lawrence. With Katz Pictures from 1989, Tom covered such international events as the fall of the Berlin Wall, the Romanian Revolution, the build up to the Gulf War and the first winter of freedom in Albania. Tom also travelled to Sarajevo several times during the fighting there, receiving serious injuries during heavy fighting near the Bosnian parliament in 1993 that prevented him working for over a year. In 1995 he was a founder member of a new agency, The Independent Photographers Group, where he has continued to produce works of excellence. Awards include the Nikon Photographer of the Year 1991 and 1992, Ilford Feature Photographer of the Year 1993, and an Hon Mention and place in the World Press Awards 1992. He also received two 2nd place awards in the World Press Features 1993. More recently he won the Visa D'Or for the most outstanding news photo essay of 1994 for his project on Rwanda. The same essay won 1st prize in the General News Section of the World Press Photo and his pictures of Rwanda were also awarded, out of 44,000 entries, the Gold prize in the United Nations Environmental Photo Competition. He won a second Visa D'Or in 1995 for the most positive photo of the year, taken in Sarajevo and featuring an amputee mother with her young daughter. Further Awards have included the Care International Award for humanitarian reportage in 1997, 3rd Place in the World Press Photo in the portrait story section for his set on the Tony Blair campaign trail and first place in the Nikon Awards in 1998 for his work on the catastrophic famine in Southern Sudan. In 2000 and 2001 he has been concentrating on the HIV/AIDs situation in sub-Saharan Africa.

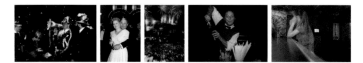

Jill Waterman studied for her Bachelor of Fine Arts degree in Printmaking at Massachusetts College of Art from 1978-1981, before continuing her studies at the Sorbonne in Paris from 1982-1985. She then went on to gain her Master of Arts from New York University International Centre of Photography in 1988. Her work has appeared frequently in publications all around the world and is represented in several collections, including the Bibliotheque Nationale in Paris, the Ludwig Museum in Koeln, the Museum of Fine Arts in Houston and the Harry Ransom Collection at the University of Texas in Austin. She has been part of numerous group exhibitions and has had several solo shows as well at venues such as the 494 Gallery in New York, The Project Gallery at the University of Bridgeport and Gallery Y at the Houston Center for Photography. Cities she has photographed to date as part of her New Year's Eve project include Paris, London, New York, Montreal, San Juan, Boston, Washington, San Francisco, Burlington, Tucson, Pasadena, Shanghai, New Orleans, Berlin, Mexico City, Edinburgh, Bethlehem, Jerusalem and Rio de Janeiro. Jills website address is: http://www.newyearphotos.com

Felicia Webb graduated from the London College of Printing with a postgraduate degree in photojournalism in July 1998. While at college she was runner-up in the Ian Parry award for young photographers, sponsored by the **Sunday Times** Magazine and Nikon. She was subsequently invited to join Katz Pictures photographic agency. Since then she has worked for several charities including Children's Aid Direct, Sargent Cancer Care for Children, and Sight Savers International. Sight Savers sent her to India to document their work to eradicate cataracts, and to Kenya to record the ascent of Mt Kilimanjaro by 11 blind and partially sighted teenagers from Britain and Africa. In 1999 she spent almost two months in Albania, Macedonia and Kosovo documenting the plight of women throughout the war. This was published as a photo-essay both in this country and abroad. She has worked recently in Mexico, the United States, and Azerbaijan, as well as carrying out stories and assignments in the UK. Since early 2000 she has been working on a long-term project on people suffering with eating disorders, which won the La Nacion International Photojournalism Award in Argentina in 2000, and the Magazine Division/Issue Reporting Story section of the Pictures of the Year Awards in the United States in 2001. In 2001 she was awarded a place on the World Press Masterclass in Holland. She previously lived in Latin America for four years, working as a staff and freelance journalist in Venezuela and Mexico.

120

Randall Webb is a freelance photographer and lecturer. He is also a leading authority on the history and practice of photographic printmaking, ranging from the work of Fox Talbot in the 1830s to Andy Warhol in the late 20th century. His interest in early and alternative processing dates from his experiments in 1968 with the now neglected bromoil process. He now runs workshops at museums, art schools and universities on a wide variety of early processes, including salt printing, gum printing, platinum, carbon, photo etching and photo silk screen. Following extensive research, he has recently published a definitive text book on the subject entitled **Spirits of Salts**, in association with Martin Reed of Silverprint – website at http://www.silverprint.co.uk, e-mail sales@silverprint.co.uk. A few years ago he founded the 120 group of photographers, and he exhibits and sells his work which is printed using examples of alternative printing.

15

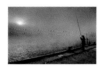

Gary Wilson was born in 1964, and left graphic design for photography in 1986. He began working in black and white darkrooms specialising in theatre photography, with associated large scale printing for front of house display. He also produced large scale prints for exhibitions taking place at venues such as the Victoria & Albert Museum, the Theatre Museum in Covent Garden, the Press Photographers' Association, Nikon and individual photographers such as Brian Griffin and Chris Killip. A personal interest in reportage photography also led to associations with many photographers in the news and photojournalism fields, many of whom became regular clients when he turned freelance in 1991. This also allowed Gary to expand his own photographic career, which is largely arts based, and which includes commissions for music, portraiture and commercial/design assignments. He also enjoys maintaining a level of diversity with his printing clients, concentrating on portfolio, exhibition and sale work, as well as fast turnaround printing for advertising and commercial work.

Glossary

Backlighting
Light that's coming from a position in front of the camera and illuminating the subject from behind

Black Reflector
Used to soak up light and to ensure that a selected area retains deep shadow

Bounced Flash
Flash that's been reflected from a surface such as a wall or ceiling to diffuse the light

Cable Release
A flexible device that screws into the camera's shutter release button and activates the shutter without the need to touch the camera

Compressed Perspective
Distant perspective that's been brought up close by the use of a telephoto lens

Depth of Field
The distance in front and behind the point at which a lens is focused that will be rendered acceptably sharp. It increases when the aperture is made smaller, and becomes smaller when the lens is focused at close quarters

Dodging
The holding back of certain areas of the negative during printing to reduce print density, allied to the selective increase of exposure to certain areas of the print that require increased density.

Downrating
The opposite to uprating, and primarily done to reduce contrast. The film is shot at a lower ISO rating and, to compensate for what is effectively overexposure, the film is developed for a shorter time

Dual Toning
The technique of placing a print in two separate toning baths to pick up elements of both colours

Farmer's Reducer
A mixture of potassium ferricyanide and sodium thiosulphate that will lighten selective areas of a print

Fill-in Flash
A weakened burst of flash that can be used to subtly fill in the shadows on a subject's face

Filter Factor
An indication of the amount the exposure needs to be increased to allow for the use of a filter. A x2 filter needs one stop extra exposure, x3 one-and-a-half stops more and x4 two stops more.

High Key
A picture that consists almost entirely of light tones

HP5 Film
latest in the line of classic ISO 400 speed black and white films from Ilford, and one that is a mainstay of contemporary photojournalism. Can be uprated by several stops if required to cope with low light conditions.

Hyperfocal Distance
The distance between the lens and the nearest point of acceptably sharp focus when the lens is focused for infinity

Infra Red film
A film that responds to the different reflecting powers and transparencies of objects in the picture to infra red and visible radiation, producing a series of bizarre tones

Lith Printing Paper
A printing paper that increases the contrast levels in a scene while allowing shadow detail to be retained. Its characteristic feature is a pink tone

Low Key
A picture that consists almost entirely of dark tones

Mirror Lock
A lever on an SLR camera that allows the camera's mirror to be locked in the up position before an exposure is made to help reduce vibration

Monopod
A form of support for the camera that utilises one leg, which makes it very easy to set up and move

Neutral Density Filter
Used to cut down the light reaching a film by a stated amount, and absorbs all wavelengths almost equally, ensuring no influence on the tones each colour will record as on black and white film

Pinhole Camera
A camera that relies on a tiny hole to resolve its image rather than a lens

Polaroid Type 55 film
One of the oldest Polaroid film materials available, which gives the photographer both a print and a negative

Rangefinder Camera
A camera that features two separate images in the viewfinder that come together as the lens is focused

Reflector Brolly
A highly reflective umbrella that attaches to a flashgun to bounce the light back on to a scene

Selenium Toning
A brief immersion in selenium toner diluted at about one part concentrate to 15 parts water should not change print image colour but it will improve the archival permanence of the print. The toner must be used in well ventilated conditions

Spot Meter
A meter that is designed to give an accurate meter reading in difficult lighting conditions by gathering information selectively from three to four areas of a scene

Tri-X Film
a classic ISO 400 speed black and white film from Kodak that is one of the most popular films ever produced for photojournalists. Can be uprated by several stops if required to cope with low light conditions.

Uprating
Rating a film at a speed higher than its nominal rating, and then compensating for the underexposure that takes place by increasing film development

Variable Contrast Paper
Photographic paper that can produce different levels of contrast depending on the filtration it receives

White Reflector
A board or sheet that is positioned to bounce light into areas of shadow

Acknowledgements Many thanks to all those who have contributed so very much to this book. To Angie Patchell, who has overseen and edited the whole project, and whose enthusiasm has helped immeasurably to drive it forwards; to Dan Moscrop at Navy Blue Design Consultants, who has worked so hard to turn a collection of pictures into a cohesive and visually stunning volume of work; to Manuela Hofer and Gary Wilson for giving so much time and advice to me during the picture research stage of the book; and to all the photographers who have contributed their work, and their expertise, so willingly. And, of course, continuing thanks to Sarah and Emilia, who have supported me throughout the entire project, as always.

The Association of Photographers Based in London, the Association of Photographers has a membership of advertising, editorial and fashion photographers, and photographic assistants, in excess of 1400, and it's also supported by agents, printers, manufacturers and suppliers of photographic equipment, as well as affiliated colleges. The Association, which supports a large and superbly presented gallery, is dedicated to fighting for photographers' rights in addition to promoting the work of contemporary photographers. Contact details: 020-7739 6669, e-mail aop@dircon.co.uk or visit the website at www.aophoto.co.uk.